Eskimo Artists

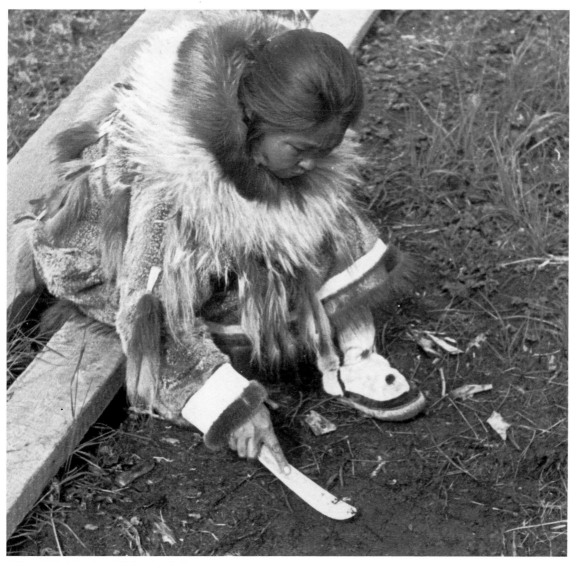

1 Maggie Lind drawing with the story-knife

Eskimo Artists

(Fieldwork in Alaska, June 1936 until April 1937)

by Hans Himmelheber

Introduction by Ann Fienup-Riordan

University of Alaska Press 1993

Library of Congress Cataloging-in-Publication Data

Himmelheber, Hans, 1908-
 [Eskimokünstler. English]
 Eskimo artists : fieldwork in Alaska, June 1936 until April 1937 /
by Hans Himmelheber ; introduction by Ann Fienup-Riordan.
 p. cm.
 Translation of : Eskimokünstler.
 Includes bibliographical references (p.) and index.
 ISBN 0-912006-69-2 (acid free paper) : $15.00
 1. Yupik Eskimos--Art. 2. Yupik Eskimos--Material culture.
3. Artists, Eskimo--Alaska--Nunivak Island. 4. Artists, Eskimo-
-Alaska--Kuskokwim River Region. 5. Nunivak Island (Alaska)--Social
life and customs. 6. Kuskokwim River Region (Alaska)--Social life
and customs. I. Title.
E99.E7H513 1993 93-32932
704'.03971--dc20 CIP

© Dr. Dr. Hans Himmelheber, Heidelberg

English Edition, paper (1993)

Reprinted by the University of Alaska Press
with permission from Dr. Dr. Hans Himmelheber.
Introduction by Ann Fienup-Riordan © University of Alaska Press
All rights reserved. First Printing.
International Standard Book Number: paper 0-912006-69-2
Library of Congress Catalogue Number:

Printed in the United States of America by BookCrafters.

This publication was printed on acid-free paper that meets the minimum requirements for the American
National Standard for Information Science—Permanence of Paper for Printed Library Materials ANSI
Z 39.48-1984.

English Edition, cloth (1987):

Cover: Fred Bauer, Küsnacht
Photolithographs: Franz Horrisberger AG
Layout: I. Wettstein + B. Kammerer, Zürich
Manuscript: Andrea Isler, Kathrin Glass
Publisher: Publikationsstiftung für das Museum Rietberg Zürich (Eberhard Fischer)
Printer: Stämpfli + Cie AG, Bern (ISBN : cloth 3-907070-12-7)
Distributed by Museum Rietberg Zürich, Gablerstrasse 15, CH-8002 Zürich (Switzerland)

German Editions:

Hans Himmelheber (b. 1908)
Eskimokünstler
(Teilergebnisse einer ethnographischen Expedition in Alaska von Juini 1936 bis April 1937)
1. Edition: Strecker und Schröder Verlag, Stuttgart, 1938
2. Enlarged Edition: Erich Röth Verlag, Eisenach (now Kassel), 1953

Dedicated to Dr. Fritz Sarasin
President of the Board of Trustrees,
Ethnographic Museum, Basle
by the Author, 1938

Contents

The Author's Itinerary in the Alaskan Eskimo Region

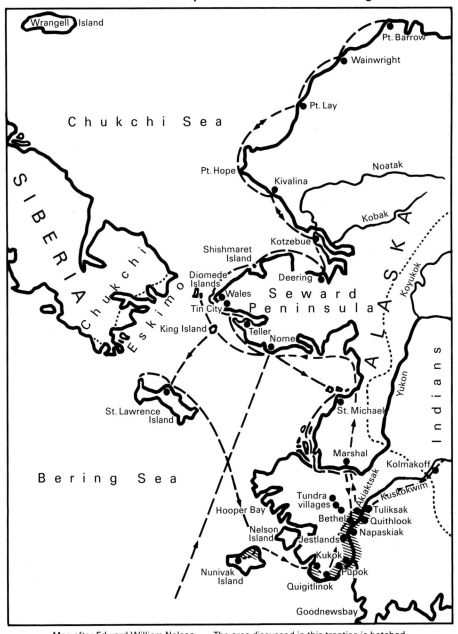

Wrangell Island

C h u k c h i S e a

Pt. Barrow
Wainwright
Pt. Lay
Pt. Hope
Kivalina
Noatak
Kobak
Kotzebue
Deering
S I B E R I A
C h u k c h i E s k i m o
Shishmaret Island
Diomede Islands
Wales
Tin City
S e w a r d
P e n i n s u l a
A L A S K A
Koyukok
King Island
Teller
Nome
St. Lawrence Island
St. Michael
Yukon
Indians
Marshal
Kolmakoff
B e r i n g S e a
Akiaktsak
Kuskokwim
Hooper Bay
Tundra villages
Tuliksak
Bethel
Quithlook
Nelson Island
Jestlands
Napaskiak
Kukok
Nunivak Island
Pupok
Quigitlinok
Goodnewsbay

Map after Edward William Nelson The area discussed in this treatise is hatched

—— by boat — — by sea or ski plane – – – by sleigh ······ border of Eskimo territory

Preface to the 1938 Edition

In May 1936, after a lecture tour to American Universities, I set out from New York to Alaska, in order to pursue there the question of the artist among the Eskimos – as in 1933 with the Atutu and Guro people in West Africa. If in this third trip I revert to the theme of my first ethnographic expedition (my second expedition took place in 1934/35 in the hinterland of the Côte d'Ivoire) it is because the friendly reception of my "Negerkünstler" obliges me to broaden the basis created through that book. Drastically shortened, this work attempts to determine whether what was found out about the Africans holds generally true for ethnic art.

The result seems to justify the study: the art of Eskimos is different from that of Africans in almost every respect – other fundamentals, other tasks, other artists, other manners of representation.

It will be shown also that Eskimo art provides a richer field of research than African art. The practice of their art has not developed into a handicraft-profession, but it contains painting and graphic art in addition to sculpture.

The work was carried out on the Kuskokwim River. When I had terminated it, I was able, through the kind cooperation of the Bureau of Indian Affairs, to travel on a government vessel up along the coast to the most northernly settlement of the American arctic, Point Barrow, and to the seldom visited St. Lawrence, King and Diomede islands.

It became evident that in that entire huge realm, not one single trace of the great art of engraving survives, of whose vanished splendor countless ivory pieces bear witness in our ethnographic museums. In tiny incised designs on their bow drills, tobacco pipes and bag handles, the Eskimos had earlier used to portray the events of the year or outstanding adventures: that someone built five kayaks in one winter, or how one killed three caribou just as

the sun was going down between two mountains. These pieces were regularly inherited and the designs were continued by the sons.

Finally I was dropped off just before the arrival of the pack ice on the 3rd of November 1936, on the Island of Nunivak to spend the winter as the only white man among the 215 Eskimo inhabitants. The Eskimos of Southwest Alaska to which group the Nunivakers and also the here discussed Kuskowagemiut belong differ in language, body and culture from all other Eskimo groups. Great merits were earned by Edward William Nelson, who, during his sojourn as meteorologist in St. Michael, north of the Yukon mouth, 1877–1881, and during trips by sledge to the Yukon and Kuskokwim, collected and published a vast amount of solid ethnographic material, together with his collections and later observations of the Eskimos of Northern Alaska.

The Nunivak Islanders and the people of the opposite coast are the last Alaska Eskimos who have remained in full possession of their old culture. As also Dr. Waugh's expedition reported, there are still people who have never seen white men – especially the women, since these travel less frequently. I participated in the Nunivak winter festivals, for which most works of art are prepared, and thus gained a sight of many things which I had only heard about on the Kuskokwim but could never witness. After five months, I was picked up by a plane of the Dr. Waugh expedition.

Back to the Kuskokwim! Its lower course and the connecting coast is the most densely populated Eskimo area. On one stretch of shore of about 500 kilometers, some 2000 Eskimos dwell in two dozen villages of 50–150 inhabitants. The part of the land close to the sea is Tundra, very flat; further up it is lightly forested and hilly. The large stream and the countless creeks, lakes and sloughs offer the Eskimos in most years an abundance of fish, besides

good fur-animal and bird-hunting, and berries. On the upper Kuskokwim live the Tena Indians, immediate neighbors of the Eskimos, but almost without contact with them.

The Kuskokwim was partly explored in 1820 by the Russians, to whom Alaska belonged at the time. They then (after 1832) promoted fur-trade with the indigenous population and much evidence still remains from their time: there are still a few small Russian Orthodox Greek-Catholic churches there, in which American priests or Eskimos hold services. Furthermore there are many Russian first-names among the Eskimos as the list of artists shows; and without tea, one starves to death.

In 1867, Alaska was bought by the United States. Since 1885, the Moravian Mission has concerned itself with the Eskimos on the Kuskokwim, and a few small schools teach the youngest generation English and useful knowledge, such as the building of wooden boats. Otherwise the influence of whites is not very strong. The natives take part in the development of the country only in the occupations they practice anyway: in trapping, hunting and fishing. They are not employed in the gold-fields, they are not needed as clerks, as administrative officials, or as soldiers. In the future they will in part supply their own teachers which the government is having educated. The American government has brought reindeer from Siberia at great expense and has had them increase in great herds, replacing the caribou diminished by firearms. The government does not encourage the adoption of "White man's ways".

"Eat native food", I read over the door of a government school. Thus, their way of life is virtually unchanged, even though much ancient cultural value is gone and must be inquired after from the older generation.

Many of the coastal Eskimos from the area north of the Kuskokwim-Delta to Nelson Island go up the Kuskokwim in summer to fish for salmon. Thus I was

able to get to know a number of their artists. They are specially marked in the artist-index, but are always meant to be included in the text when I, for the sake of brevity, simply speak of "Kuskokwim Eskimos".

The Southwest-Eskimos differ in their art from their northern neighbors in that they alone practice painting and drawing, and in that they far surpass the other Alaskan Eskimos in wood-carving; the aforementioned ivory engraving, on the other hand, comes exclusively from the area north of Norton Sound, particularly from the Seward peninsula and the King and Diomede islands. North of Point Hope there are only few ivory carvings.

Hence one can differentiate three distinct art-zones among the Alaskan Eskimos: 1) south of Norton Sound, with wood carving, especially masks, with painting and story-knife drawing 2) from Seward peninsula with King and Diomede islands to Point Hope as the main area of ivory engraving and ivory figure carving, with fewer masks and some small amount of painting on the southern coast of Seward peninsula 3) the region north of Point Hope to Pt. Barrow with only scanty ivory figure-carving. I had selected a southern group, because the graphic art of the Northern Eskimo has been exhaustively studied by James Hoffmann, even if not in Alaska itself; as mentioned, this art has died out.

Since the time of large-scale whale hunting in the 19th century, followed by the Nome gold rush in 1900, from Cape Prince of Wales to St. Michael, the Eskimos have been carving "native curios" made of ivory for the whites: salt-cellars in the form of polar-bears with holes in the heads, a great number of butter, fruit and paper knives and the like. On the Kuskokwim, the younger generation is just beginning to earn money in this way. For a long time already the results hardly have bun beautiful but good enough to be bought. In St. Michael I questioned and observed

two such artists and will mention them here and there for purposes of comparison.

My method of working differs from that employed by me in Africa in that I did not only question the artists, but had each one work for me in my presence – in some cases for days – whilst I observed and questioned them in between. Usually I had just one at a time working for me; in any case, never more than two. Later, on Nunivak, I watched a whole row of people paint and carve, on their own initiative, and hence could substantiate the impressions I got on the Kuskokwim.

I will, in order to adhere to scientific form, indicate one artist as source for every important conclusion in the text. Naturally the answers of several artists have in most cases led to these results. The especially remarkable personalities among them I will allow to speak as frequently as possible, so that the reader will develop a picture of one given artist's personality. I have attempted to describe the character of the artists in question. With few exceptions I knew the artists only as artists – the observations allowed nothing more.

It was not possible to facilitate comparison by sub-dividing this book exactly like my *Negerkünstler*. The material is so different that it doesn't allow itself to be handled in the same manner. Thus, I must, for example, begin this book with a theoretical discussion about the fundamental principles of Eskimo art, so that the reader has it clear at the outset, that this deals with a different attitude towards art than ours. Further, I must dedicate a great part of this book to the description and significance of the art works themselves, because the nature of these has been problematic in various respects until now, and the narrative painting and story knife drawing have become known only through my field work.

All life and culture questions bound up with art will be discussed in time during the course of the treatise. Whoever

wishes to instruct himself more thoroughly will find a good source in Nelson's easily accessible book and later – I hope – in my description of the Nunivakers. Just a few things should be explained here. The Eskimos of our region lived (and still live on Nunivak) in semi-subterranean abodes which are constructed with wood and are lit by a skylight. The latter is covered with a transluscent membrane of seal intestine. In each house lives one family. In addition, every village has a substantially larger building of similar construction, the men's house, the kashgee in which the men live during the day – the bachelors sleep there, too. The celebrations, which will be mentioned frequently in the following, take place here. The Alaskan Eskimos dress in furs. The most important article of clothing with sleeves and hood is called "Parka". Whenever ivory is quoted in this book, it must be taken as "walrus ivory", since it refers to the long tusks with which the walrusses root out mussels from the ocean floor.

Archeology, which through Geist's, Collins', and Ford's intensive work in the north and on the islands in the last years brought to light such interesting old Eskimo art, has not yet been applied to the Kuskokwim. With regard to physical anthropology, the Kuskokwim has been worked on by Aleš Hrdlička. In the index of source material, I cite only the works which refer directly to the Kuskokwim area or Eskimo art, since there are many Alaska bibliographies.

For supporting my work on the Kuskokwim I am first of all indebted to Mrs. Mary McDougall who volunteered as my interpreter in the region of Bethel. With her popularity and her tactful ways she succeeded in filling the old men and women with enthusiasm for my intentions. Before they began to relate they always made certain that I carried my notebook with me. Lame Jacob, one of my best informants, once interrupted himself in the middle of a long story and said: "I am telling you all this

so explicitly because I know that it will be translated to you to the point."

Dr. L. M. Waugh who travelled on the coast and along the Kuskokwim for dental research invited me to extended cruises on his motor yacht, thus enabling me to visit off the way villages and fishcamps.

Willard Olson, the only scientific minded trader of the region, helped me with his knowledge of the Eskimos. Similarly, I am indebted to Mrs. Heron, longtime nurse at Bethel, for valuable information.

On Nunivak Island Mr. Paul Ivanoff and his family allowed me to stay with them during the first three months at the village of Mekoryuk (Cape Etolin) for which I feel greatly indebted to them all. After that, when I was living by myself during two months in a little hut in another, now abandoned, village (Nash Harbor) of Nunivak Island, Mr. Arthur Nagazruk proved to be an especially helpful friend.

The ethnographical museums of Basel and Geneva had commissioned me to collect specimen for them. I would like to thank them here for their confidence. I feel equally indebted to Monsieur Charles Ratton, Paris, for financial support.

I have given painted drum skins to the museum of the College (now University) of Alaska in Fairbanks in recognition of the possibilities I enjoyed in Alaska. Immediately after my stay in Alaska I departed for West-Africa again. I was able to stay in Germany only briefly to hand over the manuscript to the printers.

Hans Himmelheber, 1938

Preface to the English Edition

Because I have not occupied myself with Eskimo Art since the initial appearance of this book, nothing has been added to this edition. I have made only a few insignificant changes.

Whilst the first edition of this book – in German – was published by Strecker und Schröder in Stuttgart in 1938, a second edition, also in German, was published by Erich Röth Verlag in Eisenach in 1953. I am indebted to Mr. Röth for devoting considerable care to a more agreable layout.

Now, fifty years after my stay in Alaska, follows this English translation. For this I am primarily indebted to Professor Wendell Oswalt on whose initiative Mrs. Dagmar Givant Gunderson excellently translated about two-thirds of the book (the remainder was done by myself). Prof. Oswalt very kindly went through the trouble of inserting valuable additions and corrections. After futile efforts to find a publisher in the United States, the Rietberg Museum in Zurich generously offered to take care of it. I feel most grateful to its director, Dr. Eberhard Fischer, who, although himself an Africanist and India-specialist, took so much interest in my Eskimo studies and gave them the chance to become known in the country whose citizens these Eskimos are.

Further results of my work in Alaska I published in a book in German called "Der gefrorene Pfad" and in an article "Ethnographische Notizen von den Nunivak-Eskimo" in Abhandlungen und Berichte des Staatlichen Museums für Völkerkunde Dresden.

After my stay in Alaska several American ethnologists worked in the same region: Margaret Lantis did profound research work on Nunivak Island, published since in several volumes; Wendell Oswalt likewise studied the Kuskokwim-Eskimos, including present time developments, which also resuled in several most valuable volumes and articles.

I should also mention that a number of publications on Eskimo Art and on ancient Eskimo Ceremonialism have since appeared, notably by D. J. Ray and Margaret Lantis. Alaskan Eskimo archeology has received enormous impulses by the discoveries of Collins, Giddings, Rainey and others.

In August 1985 I returned to the Kuskokwim and to Nunivak Island for a few weeks, accompanied by my son Martin. Of course, after half a century most of my onetime friends have died but some I did meet, notably my Nunivak-interpreter Fred Weston, and Rex Mathlaw who had been a boy of twelve then. Almost nothing had survived of the old Eskimo culture, not even the kayak. I could not show my son one of the old semi-subterranean houses and none of the impressive kashgees (men's houses), once center of village life, scene of their splendid festivals and of their daily sweatbaths. In Bethel on the Kuskokwim the Eskimos have electric light, telephone, television, huge aluminium boats with strong motors and snowmobiles, and what used to be an old joke has come true: the Eskimos have refrigerators! They are now about to lose their own language in favour of English. It is the American teachers who admonish the children to speak Yupik, the Eskimo language!

Hans Himmelheber, 1986

Publisher's Note

A short note by the publisher might be appropriate: "Eskimokünstler," published in German in 1938 with a second edition in 1953 (Erich Röth-Verlag, Eisenach/Kassel), is one of the (anyway few) non-English books found in many a bibliography but rarely quoted in the texts concerning non-Western art, because most scholars in the field seem to be reluctant to try their German. We therefore felt that a translation of this text might be welcome. "Eskimo Artists" is by now one of the remarkable, early works in ethnoart history. A few quotations from early reviews of the first German edition might be appropriate at this point: Lantis, 1942 in the American Anthropologist (44:123f) praises this study as being "the only one of its kind, an excellent introductory presentation and a good piece of work". Erik Holtved, 1962 in Man (35) ends his review with the following: "Through the authors detailed and painstaking studies... the reader is thus made acquainted with all the essential aspects of Eskimo art and artistic work at that time, the special techniques used and the personal role of the artist." The Annotated Bibliography, compiled by W.H. Oswalt in the Anthropological Papers of the University of Alaska (Vol. 13,1) honours the book as being "unquestionably the best study of Eskimo artists in Alaska".

This monograph, no doubt, is one of the very first to discuss talent, individuality, techniques etc. of a non-European art tradition. Therefore this English edition of 1987 is a literal translation of the German one of 1939 (only the footnotes show minor changes). We did not edit its original form nor did we try to incorporate any new material available through later research. It seems useful to keep this monograph as it is, enhancing it only with additional field photographs by the author.

Besides "Eskimokünstler," Hans Himmelheber has published a book on Eskimo myths, tales and oral traditions, texts collected mainly on the Island of Nunivak (published in German: "Der Gefrorene Pfad," Erich Röth-Verlag, Eisenach 1951). Some years ago, he edited his field notes, published in the Dresden Yearbook ("Ethnographische Notizen von den Nunivak-Eskimo," 1980).

We hope that our effort to make "Eskimokünstler" available to an increased number of interested people will be appreciated and that many more will share our enthusiasm for Eskimo art. May the Eskimo artists of today benefit of the insights into their artistic heritage presented in this book, available only now in English on occasion of the author's 80th birthday.

It was this monograph which for the first time brought to our notice the existance of drumpainting in Nunivak and the Kuskokwim region. Furthermore, Himmelheber was able to gain insight into the narrative character of these splendid paintings and to collect many such stories. Furthermore, this author was the first to document that especially Eskimo women draw continuous story illustrations with the story knife into the snow or mud ground, that nose-blood mixed with urine is used to paint with and that most talented artists had some physical defects – to mention but three varied samples of extraordinary information gained from this book!

Names of Eskimo Groups in the Kuskokwim Region

The Eskimos on the Kuskokwim river call themselves Kuskogwagemiut and their neighbours as follows:

Unichgemiut = "From where we have come people," i.e. those who live at the mouth of the Kuskokwim.
Znachemiut = "Inhabitants of the sea coast."
Mamdrachemiut = "Big warehouse people," i.e. Eskimos of Goodnewsbay.
Ungalaklekemiut = "Last village people," i.e. Eskimos of Unalakleet.
Kwichbagemiut = "People of the great river," i.e. Eskimos of the Yukon region.
Agulachemiut = "Between the two main passes people," i.e. the Eskimos between the two tundra lakes between the Yukon and Kuskokwim, north of Bethel.

Of course the names for the different groups vary in the different regions. What are for the Kuskokwagemiut "the people of the last village" are for the inhabitants of Scammonbay "the people of the nearest village." This explains why names for the same group sometimes differ on the maps of Alaska.

Publisher's Acknowledgments

Many individuals contributed to the publication of this book. Dinah Larsen, coordinator of ethnology at the University of Alaska Museum, first brought the book and its author to our attention. Her position at the museum gave her insight into Dr. Himmelheber's work, familiarity with the artifacts that he had donated to its collections, and an appropriate platform from which to advise us on the importance of his book and the necessity of making it more accessible to North American readers.

Bringing this edition to its final form took the assistance of two skilled experts. Ethnologist Dr. Ann Fineup-Riordan lent her expertise to the project. Her biographical sketch helps place Himmelheber's life and career in context for readers who may not be familiar with his efforts. Dr. Steve Jacobson, professor and Yu'pik language specialist at the Alaska Native Language Center, University of Alaska Fairbanks, provides the current orthography of words identified on page 4, Names of Eskimo Groups in the Kuskokwim Region.

Finally, we appreciate the encouragement and support provided us by Dr. Eberhard Fischer, director of the Museum Rietberg Zürich which published the European edition of this book. To all these people, and to the author, the University of Alaska Press offers its thanks.

Preface to the 1993 Edition

This new soft-cover edition of Hans Himmelheber's classic work, *Eskimo Artists*, deserves wide distribution. Not translated from the original German until almost fifty years after the author's field work in southwestern Alaska, the book saw publication in a hard-cover English edition in Switzerland in 1987.

Eskimo Artists will be of special importance to artists, ethnologists, curators, historians, and others with interests in and ties to southwestern Alaska. While it can also be enjoyed by a wider public, the most important audience should be those Yup'ik who wish to know more about their artistic and cultural heritage of the recent past.

Written at a pivotal time—some fifty-five years after the field work which resulted in Edward W. Nelson's monumental work on western Alaskan Eskimo culture, *The Eskimo About Bering Strait* (1900, Smithsonian Institution,Washington, D.C.: U.S. Government Printing Office), and just before the Second World War—Dr. Himmelheber's book contains a wealth of information on artists' perceptions, daily life, and ceremonial activities. His discussions of talent, materials, techniques, and the varied uses of artistic products are the only ones we have from this period and location.

The artists' information on the drumheads, window panes, and wands donated to the University of Alaska Museum by Dr. Himmelheber raise these objects from attractive curiosities to important, meaningful pieces of material culture. The information connects the objects to particular human beings with certain ideas and personal histories, enabling the viewer to see and appreciate them in a new light.

Much of the charm as well as the importance of this very well illustrated book comes through quotes from the artists interviewed by the author. In an age when many writers did not consider identifying their Native American informants, the men and women in *Eskimo Artists* are not only names but have family histories, distinct personalities, and strong opinions. They freely discuss carving, painting, storyknifing, and many other aspects of artistic expression as practiced in their culture in the late 1930s. Some of this information should cause some rethinking of past perceptions and ideas held by non-Natives about Alaskan Native art and its place in the daily life of its creators.

<div align="right">

Dinah W. Larsen
University of Alaska Museum

</div>

Current Orthography, Names of Eskimo Groups in the Kuskokwim Region

"Unichgemiut" = Unegkumiut
"Znachmiut" = Ceñarmiut
"Mamdrachemiut" = Mamterarmiut
"Ungalaklekemiut" = Ungalaqlirmiut
"Kwichbagemiut" = Kuigpagmiut
"Agulachemiut" = Akularmiut

Introduction[1]

Hans Himmelheber was born in 1908 in Karlsruhe, southwestern Germany, close to the Black Forest. He was the youngest of Gustav and Luitgard Himmelheber's seven children. Gustav Himmelheber owned a firm for interior architecture and furniture, and it is to his father's gifts and profession that Himmelheber attributes his own interest in art.

As a young man, Himmelheber studied ethnology and art history at the universities of Berlin and Munich, followed by field work in Africa. Both environments—intellectual, urban European and exotic, rural African—piqued the young student's interest in African art. In the 1930s African art had acquired prominence among Euro-Americans spurred by provocative contemporary artists like Pablo Picasso. Yet little was known about the indigenous artists. Himmelheber traveled to Africa's Ivory Coast for his doctoral research. There he observed Baule-Atutu and Guro carvers at work and interviewed them. He published his dissertation at the University of Tüebingen in 1935 as *Negerkünstler* (Negro Artists), and it became a seminal work on the technique and character of non-Western art.

Following a second expedition to West Africa in 1934-35, Himmelheber traveled to the United States. He lectured on the results of his African fieldwork at a number of American universities, including Harvard and Yale, and the Smithsonian Institution and the Anthropological Society in Philadelphia. He met such leading figures in American anthropology as Franz Boas, Ruth Benedict, and Aleš Hrdlička. Some suggested that he tackle a study comparable to his work in Africa among an American Indian group. Familiar with the work of Edward Nelson and the elaborately carved masks illustrated in Nelson's publication *The Eskimo About Bering Strait* (1899), Himmelheber determined to travel to Alaska to observe Eskimo carvers at work.

> So I went to Seattle (by bus) and got a ticket on the *Victoria*. This was a venerable old boat which each June carried almost the entire population of Nome, St. Michael, etc., to Alaska for the ice-free months. Lucky chance, at my first dinner on the *Victoria* a slender gentleman with two young companions sat down at the same table—and that was Henry B. Collins, who had just won a national prize for his discoveries in Eskimo archaeology in Alaska.

> On hearing of my intentions Dr. Collins most kindly introduced me into the characteristics of Alaskan Eskimo groups. It was he who advised me to continue to St. Michael on Norton Sound from where I might find my way up the Yukon or over to the Kuskokwim to some group still apt to demonstrate carving. (Himmelheber, 1993)

Following Collins' advice, Himmelheber continued by boat and plane to Bethel on the Kuskokwim River. There he met Mary McDougall, a teacher at the local school and daughter of an Eskimo mother and American father. McDougall volunteered as Himmelheber's main informant and interpreter. Together the two traveled daily to settlements surrounding Bethel, questioning the local people for whom Mrs. McDougall was a welcome guest.

On these trips Himmelheber first observed Yup'ik art in context. Children engaged in a pastime called "story-knifing." Groups of girls squatted close to the ground telling stories which they illustrated by drawing figures in the mud with long ivory knives. Himmelheber also saw men painting stories onto the large gutskin coverings of their dance drums: "With their own nose blood they painted adventures which had happened to an ancestor of the painter, to relate it during the festival" (Himmelheber, 1993). He judged this practice "an outstanding feature of Eskimo art hitherto unknown."

During Himmelheber's summer in Bethel he was also often the guest of Dr. Leuman M. Waugh, dental director of the U.S. Public Health Service and, in the course of his research, a frequent visitor to the Yukon-Kuskokwim delta. Waugh took Himmelheber down the Kuskokwim on his motor launch to the coast. There Himmelheber took up residence at a fish camp, urging the men to carve masks for him so that he might observe their technique with the characteristic *mellgaraq* or crooked knife.

Back in Bethel, Himmelheber took part in the annual Fourth of July activities. During a kayak race, a seal popped its head up in the middle of the river, an unusual event so far from the coast. The men at once forgot the race and began to pursue the seal. A lad of fourteen, who had never killed a seal before, was the first to harpoon the animal. Himmelheber, who had his own kayak, followed the hunters and described the "rare ceremony" that followed: "Instead of dragging the animal to the shore they drew it away from the public to a small island in the middle of the Kuskokwim. There two shamans cut the seal up without opening the body, with all the entrails inside, in parallel stripes like a huge sausage!" (Himmelheber, 1993)

[1] Thanks to Hans Himmelheber for his biographical sketch, written in March 1993, Kurt Vitt for his translation of Dr. Himmelheber's list of publications and article on Nunivak ceremonies, and Margaret Lantis for correspondence containing useful comments and suggestions. This introduction would not have been possible without their generous assistance.

After spending the summer in Bethel, Himmelheber received an invitation from the Bureau of Indian Affairs to travel as a paying guest on their vessel *North Star* along the coast as far north as Point Barrow. During this journey he briefly became acquainted with the Inupiat and Siberian Yup'ik Eskimos living along Alaska's west and north coasts, including St. Lawrence Island, King Island, and the Diomedes. When the *North Star* headed south just before freezeup, Himmelheber disembarked on Nunivak Island, where he stayed from November through March.

Himmelheber first stayed at Mekoryuk (Cape Etolin), the larger of Nunivak's two settlements with one hundred inhabitants. During the next three months he lived with the trader Paul Ivanoff, his wife Mae, and eight children. Ivanoff introduced Himmelheber to leading community members, including the old shaman, and to two young men, Fred and Ned, who spoke some English and could act as interpreters for him. Ivanoff impressed him as both skilled and well educated, having received some schooling in the lower forty-eight states.

In the 1930s the people of Nunivak still lived in semisubterranean sod houses. The men spent their days in the communal men's house or *qasgiq*, and so did Himmelheber. Along with observing village life, he also spent a week at a coastal hunting camp where the men caught seals in huge nets stretched out in the bay.

Himmelheber considered the outstanding experience of his winter on Nunivak to be his participation in their annual winter ceremonies, including the Bladder Festival, "Kokchlu'ting" or "Halving it" (possible from *qupe*— "to split," or *qupa* "half"), and "Beduchdacheluni" (*Petugtarluni*, from *petug*— "to fasten, to tie to something") or "Small things are hanging." In 1980 he published a detailed description of these experiences in an article entitled "Ethnographische Notizen von den Nunivak-Eskimo" (Ethnographic Notes on the Nunivak Eskimo). The article is straightforward description, largely devoid of value judgments and interpretation. In a half-dozen places he mentions the work of Edward Curtis, Margaret Lantis, and Knud Rasmussen, commenting that this or that feature he observed was either like or unlike what they described. His writing style is pleasing, rich in examples.

The first celebration, which he designated "Agaiach, the Women's Dance" (probably from *agayu* "mask" or *agayu*— "to participate in a religious ceremony") began on November 26 and followed a large catch of seals in the nearby bay. It consisted of a series of dances performed by the village women while the men drummed an accompaniment. Men brought presents into the *qasgiq* as their wives danced, and these gifts were later distributed to the elderly and the poor, the shaman always having the final word on who received each gift. Himmelheber contributed sugar, tea, soap, and chewing gum as his part in the festivities. Later, during the distribution of gifts, he—as honored guest—was offered a valuable walrus tusk:

> It was a delicate situation. On the one hand I did not want to reject the present. I knew, however, that ivory was scarce and valuable, and the tusk was a very beautiful one! I stated therefore that they should not present me with a gift because it was already a great present for me that I was allowed to share in the festival. There was appreciative murmuring. (Himmelheber, 1980)

Between December 7 and 12, Himmelheber was also fortunate to witness the Bladder Festival or "Nagatschuchdachelu'ting" (from *nakacuk* "bladder," literally "there being bladders there"). His lengthy description is replete with details of this complex ceremony. On the third day of the festivities, the men invited Himmelheber to participate in a sweat bath with them, which he did. He described the heat as close to intolerable: "My heart started beating like I had never experienced it before. Like all the men, I was naked. My skin burned.... All I could think about was running to the closed exit to make myself a breathing hole." An old man saw his predicament and told him by signs to bend to the floor where the air was not as hot, which he did. After twenty minutes the sweat bath concluded, and everyone washed:

> When I left and expressed my thanks, they all called out with unfamiliar heartiness "quiana, quiana" [*quyana*]—thank you, thank you. On the way I was met by the old shaman and his mother. Already at a distance he called out too "quiana, quiana," and the old woman even gave me a handshake. A bit further 'the little kayak,' our good-for-nothing-guy, called from his cache "quiana" as well and shortly after that he visited me. My Eskimo friend, with whom I stayed, told me that everyone was very glad that "I was one of them."

> This unexpected result of my participation in the sweat bath was of immense importance to me. Up to that time I had great difficulties advancing with my work....As became evident, the ice between the people of Nunivak and myself melted in the sweat bath. From that moment on I was allowed to participate in everything. (Himmelheber, 1980)

Himmelheber attributes the trouble he had gaining the confidence of Nunivak residents prior to the sweat bath in part to the spiteful words of an elderly Eskimo who had come from the mainland to Nunivak at the same time Himmelheber

arrived. Whether or not the sweat bath washed away this spite, it probably cleansed Himmelheber in more than one sense. Not only had he proved himself open to experiences the Nunivakers' valued, but he had literally cleansed his person, making himself an acceptable participant in the annual ceremonies.

Himmelheber commented that his athletic ability served him well during the frequent contests that took place in the men's house and outside during his year in Alaska. Although he usually finished up quite honorably, this was not always the case.

> When I first participated in a race with young Eskimo men, I lost pitiably. My Nunivak competitors carried their boat hooks—sticks about the length of our ski sticks—and with their aid they jumped in long paces over the puddles of the tundra, so that I who ran without sticks soon was far behind. However, I consoled myself as one of the runners also stayed behind, and we both finished the race together. But later I learned that they always do it that way: If one of them is likely to lose too much, another one stays behind with him to take half of his shame on his shoulders!

> Again, another time, the race went over the large frozen bay in front of Nash Harbor. The goal was the men's house. The course was several miles long. To my surprise a girl was to take part! She had been brought up like a boy, perhaps on the advice of a shaman. This time, on the ice, my competitors could not use sticks, so I could keep up with them. During the course, I caught up with our amazon. When passing her, I complimented her in my awkward pronunciation of her language. Then, I finished before her. And that vexed her. So she said my funny pronunciation had made her laugh so much that

> she was unable to run fast! (Himmelheber, 1993)

After three months at Cape Etolin, Himmelheber moved to Nash Harbor where he lived by himself in a tiny frame house. The local school teacher, an Inupiat named Arthur Nagazruk, became his friend. Two months later, Himmelheber left Nunivak. His hope was to find institutional support for his work and return to Nunivak for a second year. Himmelheber traveled by plane and train to Fairbanks, where he made the acquaintance of Froelich Rainey, then teaching anthropology at the University of Alaska. The Raineys, who had built their own cabin outside of Fairbanks, showed him much kindness. In appreciation, Himmelheber gave his collection of painted drumskins to "Rainey's little museum," and they remain a valued part of the university museum's collection.

Rainey also took Himmelheber to visit the president of the university, so that the young German could try to obtain the support he needed for another year on Nunivak. Himmelheber had already sold his Leica camera and part of his collection, so he needed no more than $300 to continue in western Alaska: "The president was a very kind man, but he did not have money for such a purpose. And that was the end of my stay in Alaska. I went back to New York by boat and bus, lecturing on my way at the University of Washington in Seattle and other places."

Returning to Germany, Himmelheber went on to a distinguished career as an ethnologist. Along with his 1980 article on Nunivak ceremonies, he published two books based on his experiences in Alaska, *Eskimokünstler* (Eskimo Artists) in 1938 and *Der Gefrorene Pfad: Mythen, Marchen und Legenden der Eskimo* (The Frozen Path: Myths, Fairy Tales, and Legends of the Eskimo) in 1951. He also published two short articles, "Noseblood as Adhesive Material for Color Paint

among the Eskimo" (1968) and "Inconceivable Wondrous Achievements in West African and Eskimo Poetry" (1975). Aside from these works, his research focused on Africa, where he made thirteen expeditions between 1933 and 1976. Himmelheber published prodigiously on African art and oral tradition, including *Aura Poku. Mythen, Tiergeschichten and Sagen, Sprichworter, Fabeln und Ratsel der Baule, Elfenbeinküste* (Aura, Poku, Myths, Animal Stories, and Sagas, Proverbs, Fables, and Riddles of the Baule, Ivory Coast, 1951), *Negerkunst und Negerkünstler* (Negro Art and Negro Artists, 1960), *Afrikanische Masken* (African Masks, 1960), *Die Kunst der Dan* (The Art of the Dan, 1976), and *Masken und Beschneidung* (Masks and Circumcision, 1979). [A selected listing of Dr. Himmelheber's publications follows this introduction.] Throughout his career, he delivered many public lectures on his experiences among the Eskimos, in both Europe and the United States. Twice he was guest professor in the art department at Columbia University in New York, lecturing in courses on African and Eskimo art.

Himmelheber studied medicine for six years during the 1940s at the universities of Freiburg and Heidelberg and thus became a medical doctor in 1949 at Heidelberg University. His medical dissertation was titled "Tattooing among the Eskimo" (1948). His ethnological work in Africa, however, remained his main occupation during the postwar years, with frequent expeditions in West Africa. These trips, however, were no longer solitary ventures. Himmelheber married Ulrike Fischer in 1944, and she accompanied him on most of his African field trips. She published a book on African women, *Schwarze Schwester* (Black Sister, 1957), and the Himmelhebers jointly published several books and articles.

Ulrike Himmelheber's first husband had died during the war, and her son by that marriage, Eberhard Fischer, grew up to follow his stepfather's profession, publishing on his field research in Africa and India. The Himmelhebers had two children, Dr. Susanne Himmelheber, art historian, and Martin Himmelheber, journalist, who accompanied his father twice to Africa.

Hans and Martin Himmelheber also traveled together back to Alaska in 1985 to witness the changes that had transpired since his travels in Alaska fifty years before. Arriving in Bethel, the Himmelhebers found lodging in the Moravian Seminary thanks to Reverend Kurt Vitt. That night, during service at the Bethel Moravian Church, Himmelheber was pleased to see both Fred and Ned, his interpreters from Nunivak, now grown men. During the following days, a number of old friends introduced themselves. Himmelheber had brought along slides he had taken half-a-century before, and he gave a presentation at the mission.

> Well, life had greatly changed. When I had been in Bethel in 1936 we all had our kayaks. Now the only kayak I could show to my son was in the little museum which had since been created. Anyway, Martin could stay in a fishing camp and experience true Alaskan mosquitoes.

> Finally we flew to Nunivak for two days after having announced a slide show there by radio. A terrific storm with floods of rain came up that evening, but the school was crowded anyway to see Fred and Ned and old Nanuch and all the others who since had died or grown old, as they were picking berries as children, building a kayak as a young man. Out in the village not a single one of the old underground buildings had persisted. Instead,

a sign warned the two motorcars of the island to keep to the right.

Himmelheber's work in Alaska was unusual for his time, and it remains a unique contribution to arctic ethnography. He was one of the first to describe the Yup'ik Eskimos as not merely surviving in a harsh land, but creatively responding to it. His work was remarkable in that instead of focusing on Yup'ik art as a collection of artifacts, Himmelheber emphasized drawing, carving, and painting as part of a larger narrative process. Although beautiful, a painting or carving can tell you little unless you know the story that goes with it. As Yup'ik artist John Boss explained to Himmelheber, "You must know that every picture has a meaning" (page 23). Conversely, language alone cannot portray an important event: "Such an incident must be visibly illustrated, and only then does it become solidly imaginable" (page 12).

Ironically, Himmelheber's narrative style is very Yup'ik in character—rich in examples attributed to named orators and with interpretation kept to a minimum. Just as contemporary Yup'ik elders instruct the younger generation by giving accounts of what they have seen or heard from particular persons during their lives, Himmelheber's descriptive account is replete with examples of what he saw and what Yup'ik men and women told him. True, much has changed in the last half century along the Kuskokwim and on Nunivak, just as it has changed in Germany and the rest of the United States. Yet Yup'ik orators continue to tell stories to educate and amuse their listeners comparable to those that Lame Jacob and John Boss told Himmelheber in 1936 in their effort to educate him. With this English translation of *Eskimo Artists*, Himmelheber has passed on what he learned to Yup'ik and non-Yup'ik readers alike.

Ann Fienup-Riordan
May 1993

A Selection of Publications by Hans Himmelheber, Ph.D., M.D.

1935. *Negerkünstler* (Negro Artists). Stuttgart, Germany. An ethnographic study about the carving artists among the Atutu and Guro tribes in the interior of the Ivory Coast.

1938. *Eskimokünstler* (Eskimo Artists). Eisenach, Germany: Erich Roth Verlag. There is also a second edition published by Erich Roth Verlag in 1953. Describes the results of an anthropological journey in Alaska.

1939. "Les Masques Bayaka et leurs Sculpteurs" ("The Bayaka Masks and Their Sculptors"). *Brousse* 1: 19-39.

1948. "Die Tätowierung bei den Eskimo" ("Tattooing among the Eskimo"). Medical dissertation, Heidelberg.

1951. *Der Gefrorene Pfad: Mythen, Märchen und Legenden der Eskimo* (The Frozen Path: Myths, Fairy Tales, and Legends of the Eskimo). Eisenach and Kassel, Germany, Erich Roth Verlag.

1951. *Aura Poku: Mythen, Tiergeschichten und Sagen, Sprichwörter, Fabeln und Rätsel der 'Baule,' Elfenbeinküste* (Aura Poku: Myths, Animal Stories, and Sagas, Proverbs, Fables, and Riddles of the 'Baule,' Ivory Coast). Eisenach, Germany.

1956. "Massa—Fetische der Rechtschaffenheit" ("Massa—Fetishes of Integrity"). *Tribus, Neue Folge* 4/5 (1954 and 1955): 56-62.

1958. (with Ulrike Himmelheber) *Die Dan: Ein Bauernvolk im Westafrikanischen Urwald* (The Dan: An Agricultural Tribe

in the Primeval Forest of Western Africa). Stuttgart, Germany.

1960. *Negerkunst und Negerkünstler* (Negro Art and Negro Artists). Braunschweig, Germany.

1960. *Afrikanische Masken* (African Masks). Braunschweig, Germany.

1963. "Personality and Technique of African Sculptors." *The Museum of Primitive Art. Lecture Series*, Number 3: 79-110.

1963. "Die Masken der Guéré im Rahmen der Kunst des oberen Cavally-Gebietes" ("The Masks of the Guéré in the Framework of the Upper Cavally Region"). *Zeitschrift für Ethnologie* 88, 2: 216-233. Reprinted in 1966, vol. 91, 1: 216-233

1964. (jointly with Tame-Tabmen, Wowoa) "Die Geister und ihre irdischen Verkörperungen als Grundvorstellung in der Religion der Dan (Liberia und Elfenbeinküste)" ("The Spirits and Their Earthly Manifestations as Fundamental Conceptualization in the Religion of the Dan [Liberia and Ivory Coast]"). *Baessler-Archive*, Neue Folge, Vol. XII: 1-88.

1966. "Renforcement du pouvoir des masques Guéré (Cote d'Ivoire) par une institution de la politique moderne" ("Reinforcement of Power of the Guéré Masks (Ivory Coast) by a Modern Political Institution"). *Premier Festival mondial des Arts Negres*, Dakar, Vol. 1 (1966).

1967. (jointly with Eberhard Fischer) "Einführung in das Verstandnis Afrikanischer Skulpturen" ("Introduction into Understanding African Sculptures"). In *Catalogue of the Exhibition: Plastics of Africans*. Frankfurt, Germany: City Museum for Anthropology (Staedt. Museum).

1968. "Nasenblut als Bindemittel für Mal-Farbe bei den Eskimos" ("Noseblood as Adhesive Material for Color Paint among the Eskimo"). *HNO, Directions (Wegweiser) for Specialized Medical Praxis* 16, 1: 29f.

1971. "The concave face in African Art." *African Arts* 4, no. 3: 52-55.

1972. "Fälschungen aus der Hand von Senufo-Schnitzern (Elfenbeinküste)" ("Forgeries from the Hand of Senufo Carvers"). *Tribus* 21: 91-95.

1972. "Beobachtungen über die Moral der Eskimo und Neger" ("Observations of Morals among Eskimos and Negroes"). In *Moral Wozu?* (Morals for What?), edited by Rolf Italiaander: 42-50.

1972. "Gold-plated Objects of Baule Notables." *African Art and Leadership*, edited by Cole Fraser. Madison, Wisconsin: 185-208.

1972. "Das Portrat in der Negerkunst: Bericht uber eine Versuchsreihe" ("The Portrait in Negro Art. Report about a series of Tests"). *Baessler-Archive* XX: 261-311.

1972. Masken, Tänzer und Musiker der Elfenbeinküste (Masks, Dancers, and Musicians of the Ivory Coast). Institute for Scientific Film. Goettinger, Germany.

1976. "Der Heilige Alte. Eine Einrichtung zur Wahrung des Friedens bei einigen Stämmen der Elfenbeinküste und Liberias" ("The Holy Old-One. An Institution to keep the peace among several Tribes of the Ivory Coast and Liberia"). *Baessler-Archive* XXIV: 217-247.

1976. (with Eberhard Fischer) *Die Kunst der Dan* (The Art of the Dan). In *Maskenwesen in Westafrika* (Masks in Western Africa), Issue 1. Germany: Museum Rietberg.

1976. "Verwandtschaftsverhältnisse bei westafrikanischen Masken" ("Relationships among West African Masks"). *Tribus NF* 25: 149-154.

1979. Masken und Beschneidung (Masks and Circumcision). In *Maskenwesen in Westafrika* (Masks in Western Africa), Issue 2. Germany: Museum Rietberg. A field report about the initiation camps for boys in the village of Nyor Daiple of the Liberian Dan.

1980. "Ethnographische Notizen von den Nunivak-Eskimo" ("Ethnographical Notes about the Nunivak Eskimo"). In *Abhandlungen und Berichte des Staatlichen Museums für Völkerkunde, Dresden* (Discourses and Reports of the Anthropological State Museum) 38: 5-45.

1981. "Steinmauer und Steinmunition bei einer vorgeschichtlichen Siedlung in Liberia" ("Rockwalls and Rock-Ammunition at a prehistoric Settlement in Liberia"). In *Jahrbuch des Museums für Völkerkunde in Leipzig* (Annual Report of the Anthropological Museum) 33: 86-90, plates 8-13.

1984. (jointly with Eberhard Fischer) "The Art of the Dan in West Africa." Switzerland: Museum Rietberg Zürich.

1993. Life History of Dr. Phil., Dr. Med. Hans Himmelheber as it relates to his work among the Alaskan Eskimo. Manuscript written for Ann Fienup-Riordan.

Fundamental Principles of the Plastic and Graphic Arts

The plastic and graphic arts of the Kuskokwim Eskimo are practiced for the sake of representation, not for aesthetic effect. Only where a representation is called for do they emerge, although the picture itself then always contains aesthetic aspects. If a person dies, a figure of him is created to mark his grave; a doll is carved because a little girl wants a child; children illustrate their fables in snow or mud with detailed drawings, to make the development of the plot more vivid. The connection of the picture with the aim of representation becomes especially striking through the fact that most creations are needed for the Winter Festivals, namely, entire batches of masks to influence animal spirits and for other purposes, paintings on drums and on the windows of the men's houses as illustration of adventures that the drum-owner's ancestor experienced; the same adventures are found carved on the rhythm-sticks, and the gifts that are coveted hang as miniatures carved of wood on a cord. Only around the time of these celebrations does one carve and paint eagerly in every Eskimo village; thereafter the talents slumber until they are reawakened the following winter.

The attitude of the onlooker corresponds to the aim of the representation. He sees above all the content, not the aesthetic qualities of the work of art. When I tried to establish, as in Africa, a beauty contest with Lame Jacob, who is himself an artist, by showing him a row of other artists' paintings from which to pick out the best of them, he said: "Those are all good paintings, but they don't tell me much as such because I don't know the stories which go with them."

Yet, aesthetic values are sought in the work of art, in sculpture as well as in painting. Above all, it should show beautiful lines (compare p.50). Further, the area on the drum should be filled in evenly; as Lame Jacob was compressing the story of the wooden helmet (p.19) onto the center of his drum, his wife broke in and said he should have painted his story larger. He agreed – and added a few ice-fragments. On the other hand, the picture should not be cluttered, as the illustrations clearly indicate, most of all pl.3.

For the pleasant spatial effect, the representation is made symmetrical here and there. John Boss, for example, put two birds which his grandfather had caught in a fish-net on the right and left net-poles, even though they didn't belong there (pl.61). He meditated briefly, then said: "One I will put here and one here." Lame Jacob summarized his opinion in a clear formula: "We strive to make it look pretty, and not just to dabble it in somewhere."

The painted drums are much discussed and admired during the festive days, and one or the other is coveted for its beautiful painting; but after the festival they are rolled up, washed off the next year and painted differently; and if they have burst, they are thrown away, no matter what is painted on them. The grave-figure, decorated with ivory eyes and painted red, falls over and is allowed to decay when the dead man is forgotten. Without exception, the masks are burned after the festivals. If one asks for the reason, one will always hear: "Because they are nothing. We want to see something new next year." Even if that custom originally had another purpose [Nelson (1899, p.359) and Hawkes (1914, p.17) relate that if one desires to buy masks, an equal quantity of wood for the fire had to be furnished] the aesthetic value of the mask could not, in any case, counteract it. The snow and mud drawings with which the small girls illustrate their fairy-tales are the most transient of all: they are completed with care, but then live for a few seconds only, are erased

and replaced by the next picture. No girl would think of drawing an especially nice picture on birch-bark or on skins to show them every time with the narratives, as does a story-book. The aesthetic value of the art work doesn't justify its preservation.

Even if no other inclinations give rise to the creativity of the Kuskokwim Eskimo, the desire to describe is an unusually active stimulus. Why are the tales illustrated? Why are the adventures of the ancestors painted on drums before they are related? Because the Kuskokwim Eskimos consider language an insufficient means to the dramatic portrayal of visible incidents. Such an incident must be visibly illustrated, and only then does it become solidly imaginable. When Maggie Lind was explaining to me how night-stories are told among the men, she quickly grabbed her sketching-knife to illustrate for me the incidents by means of a sketch of the men's house: how the men lie around there on the benches, here the lamp stands... For that reason, descriptions are richly accompanied by gestures. Lame Jacob told a story of the carved figures on one of the rhythm-sticks in which a man found a very rare seal with a reddish head, fast asleep on an ice-block. When he came to the description of the sleeping, he laid his head to the side on one of his hands, wagged it back and forth and snored.

Where the visible representation of events is so highly valued, the plastic and graphic arts as means of depiction warrant particular significance. The plastic and graphic illustration is not an insignificant attribute of the story, but the strongest form of visible language supplement.

For the sake of comparison, I glance back at the desires which call forth Atutu and Guro art production – other than the desire to describe, which shows itself there almost only in the masks. Are the African inclinations here non-existent or do they just manifest themselves differently?

There the desire is for aesthetic modification of the surroundings; for that reason the Atutu build their huts as comfortable homes, with built-in, nicely profiled clay furniture, painted walls and meticulously clean rooms. Emanating from this desire, innumerable implements are created as art works: ointment jars, walking sticks, and spoons are decorated with heads or figures and covered with ornaments. I once asked a Guro weaver why he didn't make himself a cheaper and better heddle pulley over which the thread-shafts of his loom were fastened, out of an iron-wire instead of in the shape of a carved wooden figure, and got the answer: "One doesn't like to live without pretty things."

The culture of the Kuskokwim Eskimo is poor in these elements. True, by contrast to the Atutu and Guro, they recognize beauty in a landscape but they don't bother to improve their environment in this aspect. Their underground or sod dwellings and even the men's houses are unadorned.

The utensils of the Kuskokwim Eskimos have generally no embellishments. I asked Charles why they didn't ever decorate the tobacco-boxes, since they are personal treasures which they take out of their pockets in pleasant moments, turning them playfully in the hand. He answered: "For what? We just want something to preserve the tobacco in so that the saliva in it doesn't dry out." They chew the balls of tobacco a short time only, lay them damp in the can, to chew them a bit more after a quarter of an hour. It is a matter of indifference to most of the Kuskokwim Eskimos how the environment looks. Art in the aesthetic sense is therefore unimportant to them.

The exceptions thus produce a more pathetic effect: a few shapeless colourful leather patches on a fish-skin bag, a timid design on the grass mat, a row of dots around the rim of a pot, two circles and a cross on the bottom of the seal-oil lamp. The only item that is decorated with any forethought is the ivory story knife with which the girls draw their story illustrations in the snow (see page 28, pls. 25–29). Most of the time it has an incised ornament on one side: a long line and a few circles that represent drums; or circles with beams = sun, or short, bent lines = animal legs. However, the contemporary picture of Kuskokwim culture is not quite accurate in this respect. Earlier there was somewhat more of the decorative, as Jacobsen's collection shows – but not much more.

Indeed, much that one would like to consider decoration, is mainly rendered for the sake of description: vessels in animal shapes or weapon cases for harpoon points with animals on the lid which Weyer so charmingly explains (page 313):

"Aside from their utility these boxes are believed to impart mysterious potency to the weapons; the hunter will put his weapons into one of them to give the articles the proper spiritual benefit, with all the confidence of a surgeon putting his operating tools into a sterilizing cabinet."

Similarly, the previously mentioned scenes engraved into ivory in North Alaska are not created so much for the aesthetic effect as to record the important deeds of the owner: how many whales he killed in the past year, how many kayaks he built.

On Nunivak and on the opposite coast we find somewhat more decorative things: an ivory harpoon socket-piece, out of which a sea lion is made through etched lines; handles for women's sewing bags, carved as seals or fish; a small ivory polar bear is attached in front of the kayak seat so that a spear can be laid thereon. Somewhat more frequently here one hears the word "ingitschi." – "Oh, is that beautiful!" Also, a comparison of the here illustrated paintings of Nunivak with those of the

Kuskokwim shows that the Nunivakers do not, in fact, depict such amusing stories, but instead, paint much prettier.

Let us proceed! Don't the Eskimos have that joy in representative performances which in Africa is responsible for a great amount of the existing artworks: chieftains staffs, display-swords, ornate fly-whisks with beautifully carved, even gildet (Akan peoples) handles? In fact, the same desire is present with the Eskimos but it is gratified in a different manner: whoever wishes to attain recognition among his fellow citizens works and saves during the year and then shares generously during the winter celebrations. Only very few products deriving from this custom also concern art: the fur clothing and boots, for instance, are chosen and manufactured to please aesthetically although in a very modest sense: a few little tails, glass beads, springs from a broken watch. Often these apparent decorations are in reality family symbols again, as described on page 24. To this category belong the labrets, ivory discs or rods which are inserted to the right and left under the lower lip, small ornamental earrings of ivory, and as the next section shows, a bit of tattooing and hair-dressing.

The thought arises that perhaps the tendency toward property-restriction could be responsible for the scanty amount of works of art. After each celebration, one gives away much of one's possessions. As a matter of fact, though, there are many things made just for gifts, and for that reason are made beautifully: for a festival, the men make pretty earrings for the women; the girls make bathing caps of bird-skins for the men so that, as a young girl in Kukok explained to me, in the great heat of the sweat-bath their brains don't start to glow. And finally, there could also be works of art that can't be given away, namely the various kinds of body-beautification. But our Eskimos let their hair hang down frayed in their faces, or at most have it shaved off all over so that a small cap of hair will stay

on, whereas the Africans twist their kinky hair, which is much harder to handle, into the most artistic hairdos. Tattooing, somewhat more prevalent in other Eskimo regions such as on St. Lawrence Island, is restricted on the Kuskokwim to two simple double lines beneath the women's mouths.

It is a widespread belief that the food-supply of the Eskimo is so scant and the climate so hard that these people are exclusively concerned with thoughts of survival. That is not the case, at least not in Alaska. In general, the natives have sufficient food, and if it runs out, it is usually because during the main hunting season they stored too little away. Winter is indeed very cold, but that is just the way the Eskimo likes it; on Nunivak they began to "thaw" only when it got icy cold: then travel by land is good because the mossy tundra is frozen solid and the frozen fish can be eaten raw. Besides, never in my life have I seen such a sunny summer and autumn as in Alaska. I wore my lightest summer clothes and went swimming every day in the Kuskokwim.

Quite to the contrary, the Alaskan Eskimos have particularly long vacations from the struggle for existence. Most animals can be trapped only at certain times of the year: salmon when they swim upstream in June and July; geese when they are moulting and are fat, in

August; fur-bearing animals in winter when the pelts are thick; on the coast, the seals and walrusses primarily with the advancing and receding ice. In between there are days and weeks without important work. They then lie idle around the men's house, take sweat-baths, carve the handle of a chopper, and talk and talk. Petroff concludes his observations of the Kuskokwim and Togiak region (page 15) with this charming and appropriate picture: "Turning away from these populous villages with their mound-like, grass-grown dwellings, upon the apex of which the natives are wont to perch, gazing out to sea or into vacancy, recalling the aspect of a village of prairie-dogs on an enlarged scale, we leave behind us the most primitive among the Eskimo south of Bering-Strait."

Work itself holds no terror for the Alaskan Eskimo; it is considered a kind of sport. A man paddles to the goose-hunt only if he feels like it.

The periods of fishing and hunting are anticipated as welcome variety. One can hardly wait to go to the fish-camps or to the seal-hunt sites, at which hastily built igloos provide shelter. I personally lodged with the Nunivakers at the beginning of December in such a little hunting village; night after night because of the cold, we could sleep but few hours on the damp ground, ate only

3 A man found a spear stuck in a piece of drift-wood which he sold for a seal – a good deal (Painter Timothy)

in the morning and evening, and then not even to satiation; and the entire day we sat outside by the bay, on the look-out behind low stone-walls, our fur pants stuffed with dry grass, but still only scantily protected against the icy wind, hands clammy with blood and blubber (we could get only a bit of drinking water and no washing water out of the ice and snow because fire-wood was scarce), and in spite of all that, my friends considered this period a sort of vacation amusement, and were oh so sad, when after three weeks the seals became sparser and they had to return to the village.

The art offers comical evidence of this attitude: in sculpture, masculine representations are differentiated from feminine ones in that, with the former, one depicts the corners of the mouth drawn up, with the latter, pulled down. Why? "Because the men are always happy," said Kusma. "They do only what is fun for them, fish, hunt, but women are usually ill-humored because they have so much trouble and irritation with children and so much hard housework."

In the biography of the Kuskokwim Eskimo there is accordingly much room for the development of other inclinations – and, as a matter of fact, music and dance exist – but plastic and graphic art does not fully exhaust this potential.

Thus is the diagnosis: a group of men whose artistic talent manifests itself in some ways, makes very little use of this talent, although the environmental circumstances favor it. The incentive is lacking, which in Africa derives from the desire for aesthetic organization of the environment, and the desire for representative creativity finds other gratification. Just as little as in West Africa do works of art arise for the satisfaction of some strong creative impulse of the artist; for it has been shown that carving and painting are done almost exclusively for festivals. In place of that, occasional but then more intensive demand for representations appears, "commodities," hence, which demand an artistic presentation simply for their ultimate purpose. Beyond that, one certainly allows for an aesthetic aspect, but never to the extent that a work of art be created or preserved for that sake.

The Function of the Fine Arts

Almost all the works of art are produced in conjunction with two of the nine various winter festivals. The reader should thus be made familiar with their most important features.

The celebrations, with one exception, are held in the winter between November and March, when the long nights must be filled. Correspondingly, most of them are mainly entertainment events. One sings, plays, takes sweatbaths and eats as much as one can. All festivals take place in the men's house in the presence of the women and children. Beside the "function of diversion," they have a social significance through the exchange of gifts, in which the individual families or two groups, such as the right and left sides of the men's house (each man has his special place there), or two villages rival in generosity. The young people prepare their gifts months in advance, even building sleds and kayaks in order to give them away at one of the celebrations. The gifts are thrown on a pile and are divided up by the Shaman or another highly esteemed person. First the old people are provided with necessities, and even a few old women are accepted, then the older patriarchs, and last the young ones, even though they have contributed the most.

Essentially every festival is carried on according to the following scheme. The host group (half of the men's house or village or single host) feeds the guests without partaking itself. Every host has his own victim, into whose mouth he stuffs food, and the guest must swallow as much as the generous giver brings – a truly jolly business! Thereafter, those who have been fed go out and the hosts hang their gifts around on the walls of the men's house. The entrance of the guests begins on a particular song. One family after another slips through the entrance-tunnel; father and mother place themselves to the right and left of the opening and the children in front of them, all in especially beautiful dance clothes – I saw on this occasion numerous mink parkas. The hosts begin to sing and drum so that the family can dance its old family dances. These are exhibitions of events from the pedigree of the dancer: of one who could paddle so fast (paddle-movement) that he had to stop from time to time during the kayak races (the dancer makes the movement of braking) in order not to leave the others too far behind; or about the ancestor who was so fat that he had to lift his stomach with his hands before he could rise from sitting on the floor.

During the dance, the father repeatedly slips out through the tunnel and returns with the gifts, a dead seal, huge bundles of walrus-leather ropes or even a full 100 metre long leather net for netting seals; a paddle which represents a kayak gift. The more he brings, the more they sing to him, and the more family dances he may demonstrate.

When the last family has danced in, the women leave the men's house and the division of gifts ensues. Thereafter the men squat around large wooden bowls of berry-food which the wives of the guests have brought, eat them empty, and with that the festival day is concluded.

The different kinds of festivals occur through modification in the role of hosts and guests or through particular manners of gift giving. In one festival, for example, the men ask the women for gifts, in that they hang small wooden reproductions of the desired gift on a stick. Without knowing who wants the "glove," or the "bathing cap," the women divide the little figures among themselves, make the objects and bring them in the men's house the next evening, where they discover for the first time for whom they have exerted themselves. The following evening the men bring them counter-gifts.

Three of the festivals do, however, differ from the already mentioned ones through an additional religious significance, even though one still gives gifts and is entertained in the aforementioned way.

The Great Feast for the Dead which takes place only after intervals of several years, is characterized by the dividing of particularly rich gifts in honour of the deceased person by his kin. The "Lesser Festival of the Dead", which was seen and described by Nelson as an annual ritual, couldn't be described to me on the Kuskokwim.

The most significant of all ceremonies and the only one which absolutely must be held annually, is the Bladder Festival. Through its ceremonies the animals killed the previous year are brought back to life. I participated in this on Nunivak. The hunters saved the bladders of the seals they killed, blew them up and hung them in the igloo or in the cache. In the bladder dwells the Lechlgach, the "little person in the animal." At the time of the shortest days, these beings are given a great festival. Every hunter ties his bladders to his harpoons and brings them to the men's house, where the bundled-together harpoons are hung up. For eight days the bladders are celebrated with a display of complicated ritual and, for the Eskimos, pompous ceremonial which makes this festival the most impressive religious demonstration of the Southwestern Eskimo. As soon as the songs for the souls are sung, the dances danced, the gifts given, the bladders painted and "fed", the fire of the souls burned out, on the last morning each hunter takes his harpoon to the bay where a hole has been chipped into the ice, and to the accompaniment of singing, pops his bladders one after the other and stuffs them through the hole, back into the sea. There the souls unite with the bones of the same animals which had been thrown back into the

sea when the animal was killed and become living animals again, and if the hunter has done everything well and right, the same seal will let himself be killed by the same hunter the following year because he has shown that he would care for the survival of the animal.

Finally, the Inviting-In Festival: In March or April, when the fur-trapping is over, the villages reciprocally invite each other to a festival lasting several days. With this goes great celebration and gift-giving, but simultaneously one devotes attention to the game and crops. One invites them to the men's house – hence the festival's name – and tries to persuade them to be abundant the next year.

For these three festivals with religious significance, the Festival for the Dead, the Festival of the Bladders, and the Inviting-In Festival, a great number of plastic and graphic art objects are produced, yet only one group with direct connection to a religious ceremony. What they mean and how they are produced or used during the festival will be described in the following under the subject headings.

Of the ''Doll Festival'' described by Nelson (p. 379) I could find no trace on the Kuskokwim. In this, according to Nelson, a small human figure of wood, is placed in the middle of the men's house and made the subject of certain rituals. Afterwards it is enveloped in birch bark and hung on a tree in a lonely place until the next year. During the year the figure is sometimes interrogated by the shamans. Since this appeared to the missionaries as true ''idolatry'' it may have been wiped out on the Kuskokwim by the first missionaries.

Painting

With brushes of squirrel hair and paints of their own fabrication of minerals mixed with their own nose-blood, and urine (see page 62), the Kuskokwim Eskimos paint pictures on their festival drums, huge tambourines covered with walrus-stomach, and on their wooden-bowls; the figures are about as large as a finger. With regard to content, they are all fed from the same source, the ancestor-stories out of which they depict important scenes. One must instruct oneself about these to understand the painting.

Ancestor-stories are unusual events that a forefather of a particular family on either parent's side has experienced. He tells them to his children and these and all following generations may employ them as painting themes. Many of these stories are completely fantastic, but however that may be, the audience never doubts their truth, for it is known that in ancient times things happened that can no longer occur.

Part of the stories are short statements of a specific event, others are long narratives. For example, it suffices for a picture that someone once found a white whale on the coast (pl. 4), or that

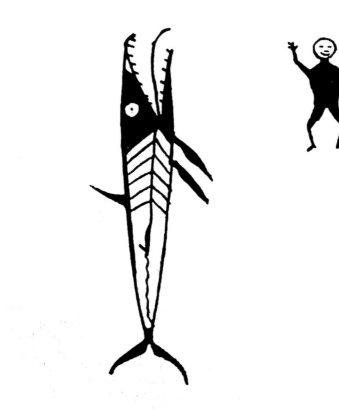

4 An ancestor found a dead white whale on the coast (Painter Timothy)

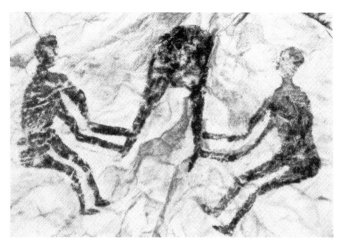

5 Two men with a walrus head

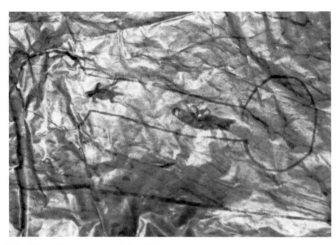

6 Seal found between two inland lakes

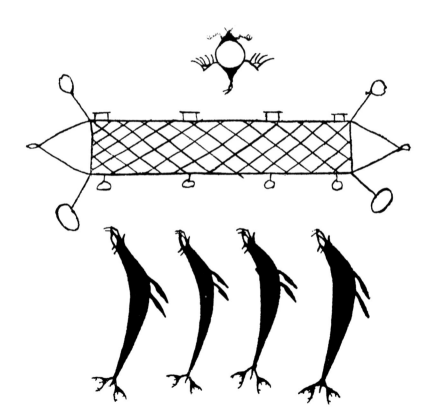

7 Four sea-lions were caught in a seal-net – also an eider-duck. Fixed to the net are weights and floats (Painter Timothy)

someone killed a seal in a creek which connected two inland lakes but had no access to the sea. The seal must have somehow moved over the land which, as Arthur Nagazruk sr., Eskimo-teacher from Cape Prince of Wales, imparted to me, actually happens. On Nunivak, one usually restricts oneself to this kind of short-story. It almost always deals with a remarkable animal-catch: one of the forefathers caught four sea-lions and an eider-duck in a seal-net (pl. 7). The next illustration (pl. 8) shows how a great whale was caught in a seal-net. They made six buoys of seal-skins in order to carry him away. This happened a long time ago with the Chigochalge-miut on Cape Corwin on Nunivak. The next drawing (pl. 9) illustrates a whale which took a whole seal net with him until he was killed by ten harpoons. Another picture shows the story of a hunter of Betkas family whose spear hit a seal at such an extraordinary angle that the spear moved along the animal's spine thus pealing off a long strip of its skin.

More dramatic is the story of two hunters who jokingly tried to break the tusks out of a walrus skull without using tools (pl. 5). Each pulled one tusk in his direction. Suddenly one of the tusks actually came loose. So vehemently had the hunter pulled at it that now the

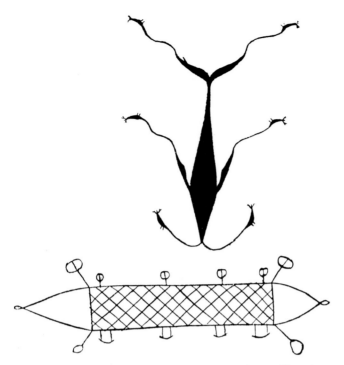

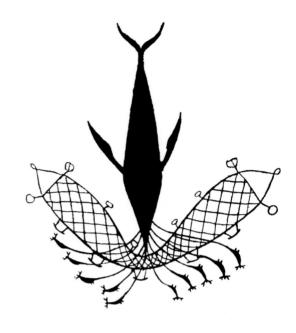

8 At Cape Corwin a huge whale was once caught in a seal-net and brought to shore with six inflated seal bladders as floats (Painter Timothy)

9 A whale once tore a seal-net and carried it off, until killed with ten harpoons (Painter Timothy)

tusk flew high up into the air and carried the hunter with it.

Again there is the story of a boy of Lame Jacob's family who when out in his kayak, suddenly found himself in the midst of a herd of seals. He grasped his harpoon, only to find that its point had fallen off. Vexed, he threw the useless shaft up into the air. But when this stick fell back onto the water – strange, it did not turn over to swim flat on the surface, but as one end of it touched the sea it remained upright and swam off in this vertical position. You see: right at this moment a whale swam by and the stick had met its blowhole and had stuck in it. Quickly, people who had watched the strange event from the shore came in their kayaks killed the whale. Lame Jacob, when a boy, had known the protagonist of this story, then an old man.

A real novel belongs to the following design, as simple as it is (fig. 10). Lame Jacob told the story with zeal and much

detail; we needed two sittings until I had written it down completely. "Once upon a time there were five men who in their kayaks intended to paddle to an is-land in the Kuskokwim, down where it meets the sea. They started around noon, but it was so far that they only reached it in the evening. The island was black with seals. They clubbed as many as possible, stuffed them into their kayaks and started their return journey in the dark.

After they had been on their way for some time, a strong southwind came up – so strong that it soon drove the men apart. However, by shouting they managed to reunite, but again and again they were separated. Thus they fought for hours. They tried to paddle with the wind behind them, so that it would drive them to the shore, but it started to rain and the wind turned, so that soon they lost all orientation.

Now there was one among them whose eyesight was not good. But it was this

one who suddenly cried out: "Do you see that little star, there among the clouds? Then the shore must be behind us!" – One of the men replied: "What does he know about stars, he who can't see properly. We others have seen no star, and we have good eyes."

The other man remained firm. "Men", he called out, "whoever thinks I am right may follow me. I am completely sure. I have seen this star frequently in my younger years."

The one who had opposed him again advised against him. "Let him paddle where he wants," he said, "but for heaven's sake don't follow him."

Two of the men went with him, and only one with the man whose eyes were no good. When the latter ones had pad-dled for some distance towards that star they suddenly felt ground with their paddles – indeed, there was the shore, there their village, and here their sleep-ing mats on which without delay they went fast asleep.

18

In the meantime the three others had paddled to and fro, and when morning dawned they found themselves so far out at sea that they could not see land anywhere. The two of them who had trusted the critic grew angry. "You will not bring us anywhere. It is your fault that we shall now perish out here."

However, there was one among them who was a shaman. He had frequently performed the strangest things when out at sea. If someone said to him: "Fetch me this or that shell from the bottom of the sea," he would just dip his hand into the bow of his kajak and fetch the desired shell from there.

Once, just jokingly, one of his companions had said: "Pull me two walrusses out of the sea." The shaman put his hand under the kayak-cover, and what did he bring forth: two walrusbabies! It was this shaman whom the others now begged to try his art to find out in which direction they would find the coast.

The shaman asked them to put a rain-

10 The story of the five seal hunters and the star (Painter Lame Jacob)

parka over him, in such a way that his arms and hands were inside it. Then he started rowing, paddling movements. After some such efforts, he said: "My left hand feels tundra moss, and my right one rests on a sandbank, with grass on it." He pulled out his hand and

really, it held a lump of moss – then the right hand, and this one held a bunch of grass. He did not throw it away, but gave each of his companions a little of the moss and some blades of grass and spoke: "We will not paddle after moss, for where we live there is no moss-tundra; let's go after the grass, as it grows where our village is. So let us paddle towards the right."

By that time, night had fallen again, and they had to paddle for many long hours, but when day broke, they had actually reached their village. All men, including the two who had been saved before, lay in the men's house when they entered limping with fatigue.

Then they all turned against the one who had distrusted their comrade. "Look at him," they said, pointing to the half-blind man. "He can hardly see, yet he saw better where we should go." (For more ancestor stories, deeds of heroes, tales, and myths of Nunivak Island see my book "Der gefrorene Pfad".)

The stories about mythological animals are numerous, either about invented animals, or known animals with singular qualitites. The stories of this kind are assembled under "Imaginary models", page 58 sq.

It is not easy to recognize how all these fantastic stories arise. Some appear to possess a real core of truth. Lame Jacob told and painted for me the story of two hunters who left for seal-hunting in their kayaks. They killed several seals and loaded their kayaks heavily with them. At that, it had become late in the day and they had to hurry in order to reach the coast before tide would drive the icefloes towards it. One of them could paddle fast and luckily reached the shore but the other one was cut off by the in-drifting ice. So his comrade grasped a bundle of leather ropes, held one end of it and threw it out to his friend who caught it and fastened it to his kayak, so that his companion might pull him ashore. He did, but the rope caught under a big block of ice, so when

he pulled again he drew the hunter and his kayak under the ice. He pulled and dragged, and the man under the water answered by pulling too, proving that he was still alive. His friend on the beach pulled desperately, but it was impossible to drag him out from under the icefloe. Minutes passed, but strange: every time he pulled, the man under the ice answered by pulling too, although by now he should long have drowned. A quarter of an hour passed, an hour even, yet he still answered. So his friend ashore did not give up. He held the line until the water went out with the tide, took the ice with it and gave the sunken man free. How was it that he had stayed alive? He wore a particularly large wooden hat, as one wears it on the water against rain and sunlight. These hats look like a pointed paperbag. In front they reach far out beyond the eyes to protect these against the gleaming reflection of the dazzling sunlight. The hat of our hunter even reached out as from the fingertips to the elbow. When he was dragged under water there remained so much air under his hat – and just in front of his nose – that he had enough of it to breathe during his terrible adventure.

Other stories are particularly gruesome, like the night stories with which the Eskimo mothers frighten their children to bed: An ancestor of Andrew once paddled down the Kuskokwim when suddenly he saw half a dozen graveposts running towards him. They had their usual carved faces (s. p. 46) but also real arms and legs like living human beings. The man grasped his bow and arrow, aimed at one of the graveposts and shot him right through. At this, all the graveposts howled terribly like wolves, and in a moment they had changed into wolves and ran away. (The picture, painted on the window of a men's house, is now in the museum at Fairbanks. It shows a man in a kayak and the running graveposts, one of them pierced by an arrow.)

Still other stories have a humorous

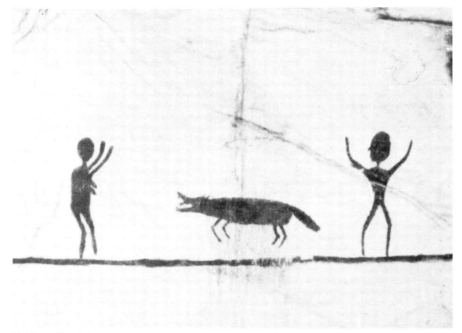

11 The wolf and the woman

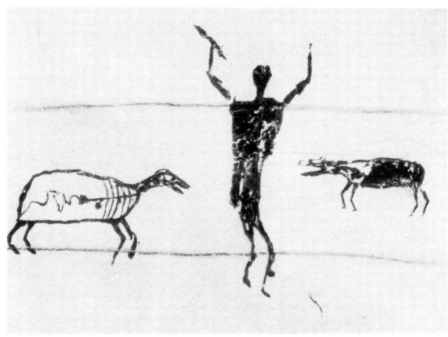

12 Killing two bears with just a stone hammer

point, as Charles' story of a man who at sea put out a huge net to catch whales. When he later went to see how many whales he had caught, what did he find in his huge net? a tiny little rabbit!

Or this one: A young man and his girl-friend went on a walk in the tundra when suddenly a wolf stood before them opening his bloodthirsty mouth (pl. 11). The young woman had the bright idea to throw off all her clothes, and there stood that wolf just rooted to the ground in amazement. He had seen many strange things in his life but never such a funny creature!

Finally, one reports and paints deeds of heroes, sometimes accomplished by a forefather, sometimes witnessed by him. They are not told, however, to glorify the heroes, but only as experiences. Thus Charles tells of a man who was so valiant and strong that he killed two bears one after another with just a normal stone hammer (pl. 12). Again the hero of plate 13 was so old that he could hardly walk any more. Yet one day he pulled himself together, and believe it or not, killed four caribou!

Or this one: One day a number of men went out hunting in their kayaks in the Bering Sea. They saw a huge walrus lying far up on the beach. It slept and had overslept the outgoing tide. That's why it was so far from the water now. The men landed and held council on how they might best attack the huge animal. Then one of them said: "Now you all stay here. I shall get it!" He laid his harpoon aside and thus, without any weapons, he approached the walrus. "You are crazy," his comrades shouted after him, "look at its huge tusks!" He simply replied: "Wait and see," and proceeded towards the animal. So the others stayed behind. The walrus lay there with its hindflippers towards the hunter. He approached it cautiously and when he was close behind it he suddenly grasped the flippers with both hands and stemmed his feet firmly in the ground. The walrus awoke, but to their astonishment it did not get excited

but just glanced at the hunter and then waddled towards the water. The hunter stemmed himself against it with all his force but the animal was so strong that the man's legs dug themselves deeper and deeper in the sand. When finally the walrus reached the sea he was burried to his navel. He stuck fast, but he did not let loose. At this, the others got their weapons from their kayaks and speared the walrus. But so mighty an animal was it that each time when a spear hit it, it did not penetrate altogether, but on reaching the other side of the skin inside it rebounded so that the point came loose and the shaft flew out in a high arch. The hunter however held on to the flukes until the animal was dead!

As in this story, where an embellishment is added by the backflying shaft, so do many of the narratives have longwinded embellishments. Mostly these seem completely unnecessary and appear to water down the force of the story rather than improve it. But the Eskimos obviously feel quite differently about that. With special relish one likes to add that the animal which was killed in an extraordinary manner was not an ordinary animal of its species, but rather possessed of some remarkable qualities: An ancestor of Charles once succeeded in killing seven reindeer in one day (pl. 14). The first and the second one were not ordinary reindeer, but each had a large hole in the middle of its body and one of these had a human face – as the painting shows.

Equally superfluous seems the insertion of sorcery into the otherwise most charming of my stories (pl. 15). When the great-grandmother of Kusma's wife had lost her husband she decided to return over the tundra to her native village. It was winter. Her four children were with her . She placed all her belongings on a sled. When night fell she had not reached her village yet, so they had to camp in the snow. They carried a small grass mat with them. This they now fixed on four poles to form a little

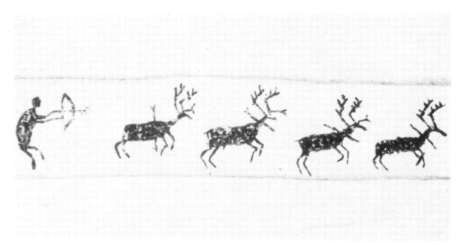

13 The lame hunter who killed four caribou in one day

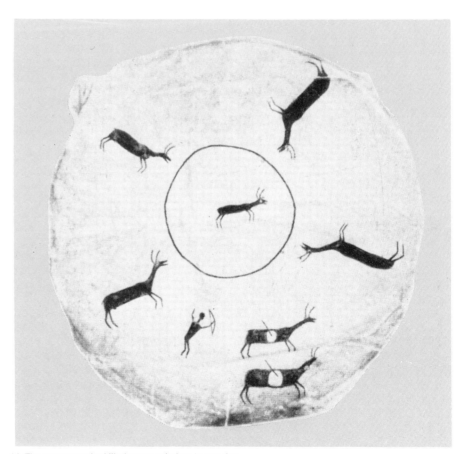

14 The ancestor who killed seven reindeer in one day

21

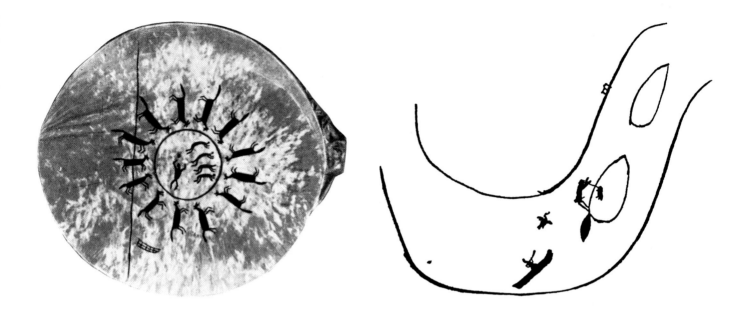

15 The mother and the wolves

16 Only a few minutes apart, the painter killed the two rarest animals: a swan and a porcupine (Painter John Boss)

roof above them. During the night the widow awoke from a whistling noise. She sat up and glanced around. They were surrounded by wolves! Crammed against each other they came closer. They did not howl, but just made this weird noise with their snouts. The widow carried a little sealoil lamp with her, as the painting shows. She grasped the first one of four moss-wicks. She struck fire and lit the lamp. But it did not work, and she had to use some magic until at last with the fourth wick she succeeded. She held the lamp up, and above her and her children's heads set fire to the grassmat. At this, the wolves turned and fled, howling. When the children heard the howling, they woke, and the youngest (extreme right on the painting) and the second youngest (next to him) were so scared that they nearly died. One third of the wolves fled in a northerly direction. As the widow had observed, these had had tattered faces as if they had gone through great hardships. Thus the painting is meant to show them: the wolves have strange upper faces, swollen upper lips, bruises. The other two thirds were normal wolves. They fled in an easterly direction. The widow and the children however could not find sleep again. They packed their sled and happily arrived in Nunatshak, the village in the tundra which has now the government school.

John Boss said, at the conclusion of an interrogation, that he now wanted to show me just how such a story came to be (fig. 16). "It was once in September that I left from here in my kayak for the island (we can see it from where we are standing). When I was almost there, I heard the cry of a swan from the land. I look up, the swan is just flying away over my head. I shoot and down he falls. Then I paddle further to the island, and as I'm arriving a minute later, a porcupine runs away, I after him, and I strike him dead with my paddle. Unbeliev-able, isn't it? Here where swans are so rare and porcupines scarcely ever appear." Then he painted me the picture. Later Lame Jacob saw this painting. He and his wife looked at it for a long time, while I asked them other things; but finally they could endure it no longer and asked me to please tell them what kind of story belonged to it. I told them the adventure, and they listened enthralled. At the end, Lame Jacob exclaimed: yes, that was really something out of the ordinary; John Boss is completely right, that he should make this one of his family stories.

The epoch of the stories can still be determined in many cases because the name and generation of the hero are known or the accompanying circumstances give a clue to the time of occurrence. As related, the widow with the wolves was the great-grandmother of Kusma's wife, and the story of the swan-flyers took place during the time that the Eskimos warred

against each other, thus at least 80–100 years ago.

From generation to generation the stories expand in proportion to the family. Lame Jacob said, he sometimes hears one of his family stories in another village and thus knows that the man (the artist) must be a relative of his.

"You must know that every picture has a meaning," explained John Boss, who was the first to paint a drum for me. "We never paint something told to us by a stranger, but only what has happened in our own family, except if someone comes who can't paint and asks me to paint him a drum with one of his stories. One doesn't, however, paint something that has happened to oneself, but only what one's father or grandfather or some other, even older forefather has experienced. If something rare happens to me, as the story of the swan and the porcupine, I will tell it to my son and someday he will paint it. Thereby he will explain to everyone what happened to me, and he will present the drum to someone after the festival, who will take it home with him and use it at the festival in his own village."

Later he brought me a whole armful of rolled-up drum-skins, some with paintings, which he had acquired in this manner.

Lame Jacob explained to me that one paints a drum only if one is one of the hosts. Every festival has a few main organizers that provide most of the food and especially valuable gifts. When the time of the festival approaches, it is asked around the men's house who wants to be a host.

One man volunteers in order to honor one of his children by means of this festival. A son or daughter is honored only if he is the favorite of the father. The occasion is provided by the first "manly" deed, for example, the slaying of the first seal by a youth. At such a festival one likes to tell something about the family to give it a personal note. Yet the drum-paintings are done only for the Inviting-In Festival, at which time the

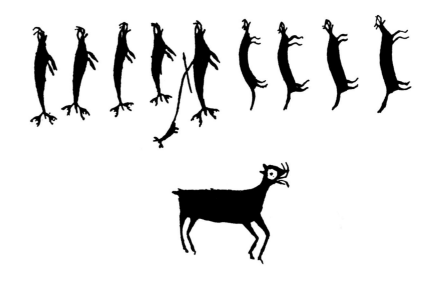

17 A hunter killed a seal and a mink alternately – he did this four times and then, that same month, he also killed a Lovetug seal and a Dachtuli (Painter Timothy)

great number of participants justifies the great number of drums. On Nunivak I saw at the Bladder-Festival the huge main drum. It was made and painted by the shaman to honour his grandson.

"While the guests eat," Lame Jacob said, "the owner of the drum stands up, drums two or three times so that everyone will pay attention, and then he tells them the story. When he is through, he says: 'So, and this drum I would like to present to the village of Tuluksak for its men's house.' Someone from Tuluksak calls: 'Excellent, hand it over!' And he is from then on the owner. The guests who hear the story for the first time are quite interested," added Lame Jacob.

Fundamentally, painting and narration are a question of praising a happy memory of an ancestor, as one also sings the favorite songs of the forefathers and presents their particular characteristics in dances.

The same stories are als painted onto the rectangular covering of the sky-

light of the men's house for the Inviting-In Festival. The window is about a square metre large, sewn together with 10 centimetre wide strips of seal-intestine. When the messengers from village A bring the wishes for certain gifts to village B, as is related on page 40, then a man in village B makes a men's house window, paints it with one of his family stories and gives it to the messenger in the name of his village as a sign of acceptance of the invitation. If the guests then come from B to A, they find their window stretched over the men's house, the story of their fellow villager nicely painted against the sky – and thus it remains throughout the entire festival.

This scene-painting occurs only in one part of the southwest area, namely from Kuskokwim to Nelson Island. Beyond that one finds only beginnings – some single animal on a drum – but no vivid scenes.

23

Ownership-Marks

From the ancestor stories, the Kuskokwim Eskimos make themselves ownership-marks which they apply to every possible implement: to bowls, spoons, weapons, tools. Their original purpose was to indicate ownership, and exclusively in this respect they are still cut into harpoon heads, reduced to a few lines and prongs; if the seal wounded by it gets away and later is washed ashore elsewhere, the finder recognizes by the weapon-point which man from what village owns the seal. On the bowls and spoons, however, the ownership-marks are drawn as small pictures, and this painting constitutes the prelude to the annual Bladder-Festival, whose entire first night is dedicated to this purpose. I participated in this on Nunivak, as described on page 70, and had the impression that labelling the item is no longer the main purpose of this custom, but that here the aesthetic enjoyment (coupled with the joy in the reproduced family stories and the activity of painting) has obscured the originally practical reason. This is verified in the fact that besides the painted ownership-mark inside the wooden bowl, one cuts another ownership-mark outside on the bottom of the bowl, a sign, thus, which can't be washed off, and which frees the painting from its original function as indication of ownership. It should be emphasized that the paintings, as Rasmussen has already determined for the incised marks of the Northern Eskimo (*Across Arctic America*, 1927, page 320), in my view do not have a religious significance. They were however repeatedly described incorrectly in literature as "totemic-marks."

A surprising variation of this ownership-mark – but without utility of any kind – is found on the fur-garments. Through insertion of certain pelts or additions of tails one indicates an event. In a war, the great-grandfather of Kusma shot a man from Bristolbay with his arrow through and through, in on his

18 Parka with two white angles (worn by the author)

right shoulder, out on the left one, as Kusma's drum painting (pl. 22) is supposed to show. Since then his descendants sew two little tails on their parkas, one in front on the right, the other left on the back, to indicate where the arrow went.

Lame Jacob's wife had an ancestor who once caught a seal's eye in his fishnet. Since then the women of this family sew an ornament supposed to resemble a seal's eye onto their parkas, and the men paint the same into their spoons.

Two white angles on the parkas made from reindeer skin are probably a very old sign, because they occur widerspread (pl. 18). Here is the story behind them: Once there lived a young man who was an extraordinary eater. Whenever a reindeer calf was killed he brought it to his wife who cooked it – and he ate it all by himself. One day he was again hunting and killed a huge moose. He started to skin it with his

knife. When he was just about to eat one of the hindlegs for his breakfast he found himself surrounded by a troop of warriors. They shouted: "We have heard that you are a great eater. So you just eat the leg you have cut off." They thought that would be impossible, laughed and shouted: "Go ahead, don't get tired." Our young man didn't mind at all. He had intended to eat this moose's ham anyway. However, he knew that these warriors just wanted to have some fun with him, to kill him afterwards. So he pretended to have great difficulties in eating all that meat, that it caused him pain to swallow each bite. Then all of a sudden he pretended to vomit – but it was only saliva. As he was spitting, he withdrew pace after pace from the warriors who of course did not want to stay close to the vomiting man. When he had reached the summit of the hill he turned and laughed and then, just to defy them, he spat once again over his shoulders and

19 Incising an ownership mark

20 An ancestor saw a reindeer with a human face: a) as a bowl mark, b) incised in the bottom of a bowl, c) as a property mark on a harpoon (Painter Andrevska)

disappeared. From all his spitting there were two white streaks on his parka, and those dumb warriors had thought he was vomiting! So to commemorate this clever ancestor his family started to sew those white angles on their parkas, as can still be seen today.

There are no ownership marks on basketry or on pottery.

With ownership marks, the main scene of the story is condensed to the most essential event. Lame Jacob's seal's mouth with moustache (see page 26) becomes two arches for the moustache hairs.

Andrevska has a broken line with three branches (pl. 20) on his harpoon points to which belongs a touching story:

His great-grandfather once was short of food-provisions, so every day he went out to hunt reindeer. But he didn't even see any! Then, one day, as again he lay in hiding, all of a sudden he saw a reindeer coming towards him, and this reindeer was snow white in front and coalblack behind. And when it came closer he saw it had antlers like a reindeer alright, but under them a human face! He became very scared of that magic animal and tried to hit it at its back, for in front it looked like a man. He shot, but hit it in front, and it fell dead. When he approached it and saw it lying there with its human face he did not dare to cut it up and just left it lying there. On his way back he thought: Maybe this was a sign for bad luck? And he became very scared. As he went on he got more and more afraid, and in the end he did not dare to return to his village. He went to his fishcamp, turned his kayak upside down and crawled into it. Thus he cowered in his hiding place, and so great was his fear that some evil force was after him that he wished he would die. Really, his strength dwindled. – Well now, over in his village was his little child who crawled around their house and had seen him disappear in the fishcamp. On all fours it crawled to the camp to play with father. And it just reached him when he was dying. As he saw the dear little thing, joy came back to his heart. He tought of his wife and brothers, took his child by the hand and returned to his village.

Out of this story Andrevska's family takes the human face with the reindeer antlers as family marks when painted (pl. 20 a). When it is to be cut on the outside of the bottom of a wooden bowl it is reduced to plate 20 b and, if there is little space as on a harpoon point, it is further reduced to the above mentioned broken line with three branches plate 20 c.

Usually one has more than just one mark, each one then belongs to a certain class of objects: one for the spoons, one for the bowls inside, one for outside, and so on. Lame Jacob, for example, paints in his spoons either a seal's eye according to the just related story, or a swan's foot, because the same fisherman once caught such a one. This swan's foot he uses, besides, as the incised mark on the outside of a bowl; inside of the bowl he paints, among other things, a wolf with a human body, because one of his forefathers once shot a wolf with an arrow, and upon closer scrutiny discovered that the dying wolf was a man below the neck. Lame Jacob added to that: "He wasn't completely dead; that's why he was half human." And then he said slowly, as if it were something especially sad, so that I wouldn't question him further about it: "And there the wolf lay dead, half human, half wolf." Lame Jacob was particularly wealthy in marks. There was still another seal's mouth with moustache to which this

25

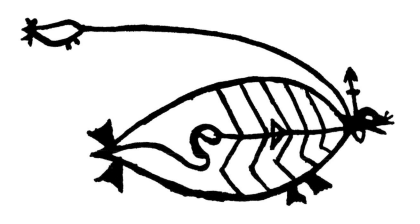

21 The rope of a harpoon strangled a seal (Painter Lame Jacob)

the neck of the animal and strangled it to death (pl. 21).

There are no strict rules concerning the fixing of particular signs to particular objects. Many Eskimos deal with their designs just as it suits them, putting one here and the other there, and later just the opposite.

The designs are inherited through both sexes within the family, but fairly informally. Lame Jacob's wife sometimes has her husband paint the design of her father, not of her mother, on the bowls. It is a whale with a large moustache which she likes especially. Whoever of my readers should possess such a bowl would easily be able to determine whether it belonged to a man or to a woman: the rim of a woman's bowl is slightly concave on the top, that of a man's bowl is flat.

story belonged: A boy scooped snow. After it had grown dark suddenly he lifted something on his shovel and what was it? The snout of a seal with its big moustache – he had cut a dead seal with his shovel just under the snout. Another time again when snow-scooping his shovel got stuck somehow. Thought he: Shall I again catch a dead seal? No, this time he pulled out reindeer antlers. Since then his descendants keep a seal's mouth and the antlers as a family mark – the latter as an incised one. "But the story does not end there", said Lame Jacob. "When the boy grew up he became an exceptionally successful hunter of seal and reindeer – that had been the meaning of those finds. Again Lame Jacob had a seal as a family mark. To this the following story belonged: One of his ancestors threw his harpoon at that seal when it lay on the ice, but hit him in such a queer way that the head of the harpoon slid on the skin of the animal, but the line wound itself around

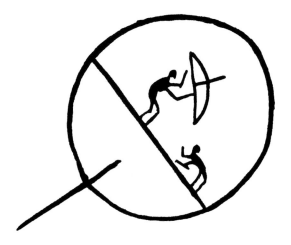

22 The ancestor shot an enemy with an arrow, which penetrated his chest and flew out through his back (Painter Kusma)

26

Paintings as Charms

On their kayaks and on their kayaks alone do the Eskimos paint figures for magical purposes. Over the entire hull of the kayak they paint a figure to make the kayak faster, or one on either side to maintain the balance (pl. 24).

For the first purpose one selects an animal which is known for its speed: a mink, fox or wolf, as the mink on the kayak of the following picture (pl. 23).

It is a drum picture which illustrates the following ancestor's story: Noatach saw two seals. He had two harpoons but only one float. He therefore tied the two harpoons together to that one float and thus he quickly harpooned both animals who were thus kept above water by one and the same float. – The mink is seen painted along the outside of Noatach's kayak.

The picture of a single human figure fulfilled the second purpose: keeping the kayak in balance. The figure is painted with outspread hands under the kayak as if it was clinging to it with arms and legs to prevent it from tipping over. On Nunivak the following story is told about it: Once upon a time there lived a man whose grandmother was a powerful magician. He always had difficulties with his kayaks and several times turned over. But when his grandmother died he had an idea. What if he could use the forces inherent in her to stabilize his kayak? He skinned her and fixed the skin under his kayak with outstretched arms and legs. And really from that time on the kayak never again turned over. It was obvious that the woman magician took care of her grandson's kayak. Unfortunately the ancestor's skin wore off from pulling and pushing the kayak up and down the beach and at last it fell to pieces. At this the grandson decided to replace it by a painting and it soon turned out that this had the same effect. Others imitated him and thus it came about that nowadays one can see kayaks with a human figure painted on far beyond Nunivak Island (compare also page 44).

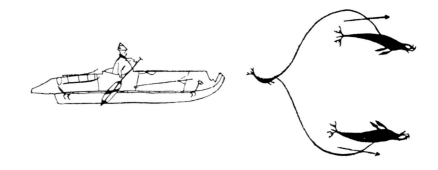

23 Noatach caught two seals with one float (Painter Timothy)

24 Kayak with magical painting

27

Drawing

Eskimo women and girls down to the very smallest are passionate story-tellers. And they don't just narrate the stories, but combine them with two other arts: singing and drawing. In almost every story there are several song-interludes with specially composed melodies, and if the story is told by daylight, the "narratress" accompanies the story from beginning to end with drawings, through which she presents the development of events in movie fashion. In winter, the drawing surfaces is the snow and in summer, the mud on the shore of the river or dirt loosened and smoothed with saliva. The only drawing tool is a large knife-shaped implement made of ivory, sometimes of wood, antler or bone (pl. 25). Jacobson had already seen such knives. He describes them (Woldt, 1884: 259) as "bone knives held in the hand during speaches and when describing localities." They are some thirty centimetres long, two to three millimetres thick, and two to four centimetres wide. All knives conform to the same type; only the scanty embellishment of the handle and an ornament on the knife surface are a bit modified. They have a fairly dull blade and on the back of the point a few prongs which are also employed in the drawing. The ivory knives are usually slightly curved around the longitudinal axis, which is not intended but occurs through a peculiarity of the material: because of the width of the knife it must be carved close to the core of the tusk, and is thus often half-core, half-good-ivory. This disparity in the material effects the distortion, resulting in this crooked shape.

We find the storyknife in the hand of a small girl, who, with a handful of other girls, squats on the ground or lies on her stomach and tells them a story (pls. 26–29). These groups of children belong to the village-picture just as chickens to a Black Forest village; one sees them at every step and at all times

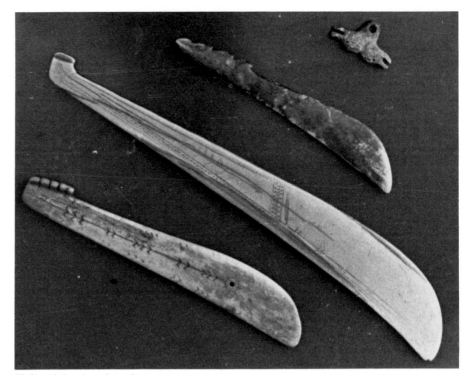

25 Story knives in various shapes

of the day; the story-drawing is the greatest pleasure of a girl. One immediately notices the group because the children seem to have something very important to do. They put their heads close together, don't look around, and one sees then, how the narratress alternately draws with the cutting-edge, and then, after she has turned the knife around, with the prongs on the point, spits on the drawing, smooths the ground again and draws the next scene. She holds the knife almost in the middle, index-finger on the back. Long lines she draws; short ones are simply compressed (dots with the prongs). The knife does not rest for a moment, for she illustrates and explains through drawings every narrated sentence. She pauses just long enough to sing the speech of a protagonist. Here, now, are two such stories:

"Once upon a time there were two women who were so old that they lived just as happy as two little children. (If the narratress takes pleasure in details, as is usually the case, she now erases the first picture and draws the figures about hand-size in their attire and dwells on portraying the details; then she will wipe out this drawing, produce another one, placing the now more simplified figures into an igloo.)

Thus they lived in an igloo on a slough, you see, and here were their sleeping places, here the entrance tunnel and here the door and this is their kayak put up on a scaffold. Once during the night, when the two little old ladies were peacefully asleep, a tiny, fingerlong needlefish came swimming down the slough. It sang (the narratress sings):

Oh yes, I am the strongest
the strongest am I
On the other bank there
if I were on that sandbank (with the two old ladies) – Whew! I am so strong
I could eat them on the spot
eat them raw
I shall cut them right in two.

28

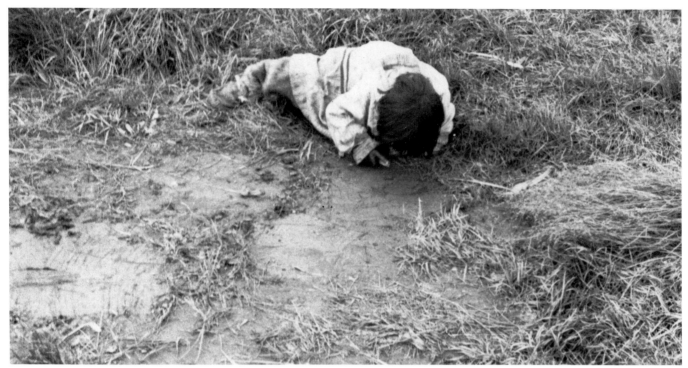
26 Small girl drawing by herself a story into the tundra ground

One of the two grandmothers woke up and heard the terrible, threatening song. She shivered and trembled with fear for she thought it was an incarnate Dunnerak, a ghost. She crept out of her sleeping-skins, over to the other woman and bit her ear to wake her up. 'A Dunnerak is coming', she whispered. They got up as quietly as a mouse, grasped all their clothes, carried them to their kayak, pushed it into the water, then sneaked back and fetched the dishes, the dried fish, then even the little oil lamps and, finally, they packed their entire underground house into the kayak, yes, even their well and finally they rolled up the path which led to the little hut where they used to dry their fish and also the path on which they used to go out into the tundra to pick berries and stowed them all in their kayak. (While telling this story, the girl depicts each mentioned object, or if she has already drawn it she points to it and draws a line from this object to the kayak.)

During all this time the awe inspiring song went on. At last the little old ladies had all their belongings stowed in the kayak and now they placed themselves in it back to back. One of them held her big fish-cutting knife in her hand, ready to hurl herself on the Dunnerak at any moment. Just when they wanted to pull off, one of them remembered that she had left a spoon behind. She disembarked and ran back. When she returned to the kayak and just as she was sitting in the kayak again, the tiny little needlefish came swimming past, singing its terrible song. When she saw that it was this little chap who had been singing, she exclaimed: ''What, you little thing has thus frightened us?'' With her spoon she reached over the kayak and simply scooped the little fish out of the slough. ''And you were singing that you wanted to cut us in two and eat us raw! Now we shall proceed with you in just this way!'' She took her long knife, cut the little fish right through,

gave half of it to her companion and they ate it raw. Then they took all their goods out of the kayak, put up their house again – and if they have not died since, they still live there''. (The last sentence was actually pronounced by Lame Jacob's wife almost exactly as we do in our fairy tales. She finished: ''And stayed there forever''.)
Usually the stories are much shorter. Thus plate 29 illustrates this story:
''A girl walked on the ice of a river between two mountains. She walked day and night, but she could not get further than the two mountains. After a while she heard that from either bank somebody called her, asking her to come over. She went to the left bank and found a woman whose house was very clean. This woman told the girl not to go to the other woman on the right bank. However, after a while the girl felt bored and inspite of this warning went to the other bank. She found a dirty, evil smelling house in which an old woman

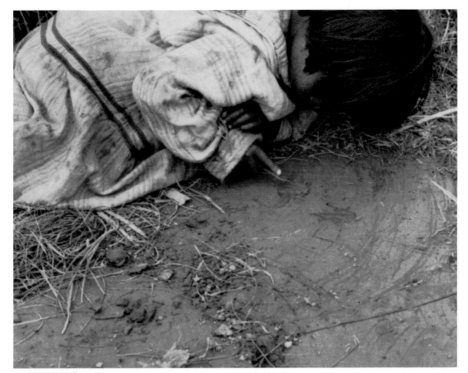

27 Drawing while story-telling

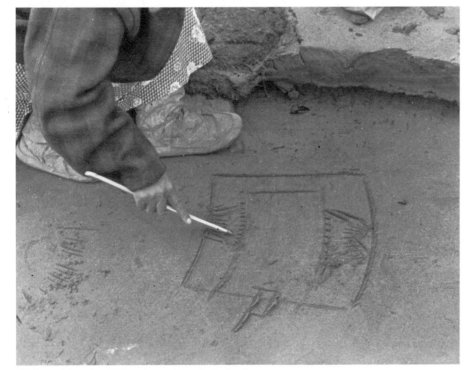

28 Groundplan of an Eskimo-house. Story-knife drawing

lived with her granddaughter. Whilst the woman on the left bank had worn a parka made from squirrel skins, this girl only had one made of seal skin. During the night the girl woke and saw that the old woman sharpened her knife. The girl hid – and the old woman by error cut her own granddaughters head off. The girl however returned to the other bank and remained with the good woman.''
The last illustration is then erased and the next narratress takes over. It is scarcely imaginable how beloved this pastime is. On an almost dark, foggy cold night in Kukok around two o'clock I saw a woman telling stories to some girls on the shore. If they are unable to find comrades, the girls draw and narrate to themselves. One may see them sitting, scratching and talking to themselves there in the mud.

It is all the more surprising that drawing is practiced commonly from the Kuskokwim to the Yukon, but is completely

29 A river between two mountains. Story-knife drawing

unknown on Nunivak. Also, no drawing-knives have been excavated from the old village-ruins there, whereas I myself have found these on the Kuskokwim.

Note:
1. Later archaeology on Nunivak Island confirmed this, see van Stone's article in Anthropological Papers of the University of Alaska 1956.
2. W. Oswalt published further observations on the subject of story-knife drawings and forty-one stories which go with it in Proceedings of the American Philosophical Society, 1964, V. 108, no. 4, pp. 310-36.
3. In 1985 one Eskimo woman in Bethel told me that at their first menstruation the girls had to hand over their story knife to her mother and quit this girlish play.

Perhaps this was not generally practised. At any rate, Maggie Lind, as shown on plate 1, and another woman did not hesitate to draw stories for me.

Sculpture

Masks
The Kuskokwim Eskimos recognize three types of masks according to function:
1. Animal and plant masks for the purpose of influencing the hunt and the "harvest" of berries, grass, etc.
2. Actor's masks for the presentation of stories or for humorous performances.
3. Masks of the helper-spirits of the shaman.
In the area visited by me and north of it there seem to be additional masks of animal guardian spirits, animals which have selected specific people as friends and wards.
All these masks are used only at the Inviting-In-Festival, with the exception of the below-described Ichzit-Forehead masks which also appear at the Festival of the Dead.
The masks are worn by men only, who

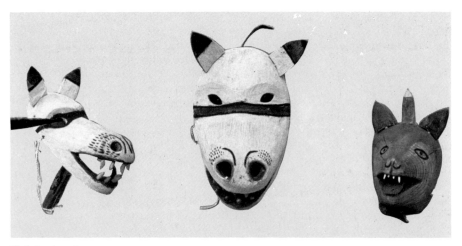

30 Animal masks

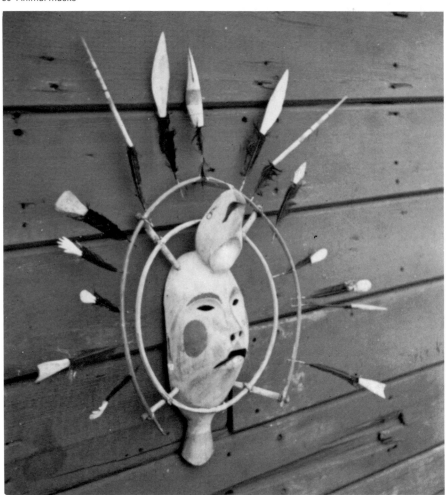

31 Mask of the seagull with fish

31

come forward because of their dancing talent.

For one festival about two dozen of the animal and plant masks are prepared. They display, often in pairs (masculine and feminine, pl. 30) the animals and plants which seem essential to the Eskimos; among the plants are above all berries and weaving grass and sometimes also animals which appear in connection with useful animals – sea-gulls with fish for example (pl. 31).

In the dances either the animals themselves are imitated or events and gestures which are bound up with their appearance. For the latter, one adds all kinds of wood-carved "insignia", symbols of things connected with the animals: traps, ponds, etc. Unfortunately I have never seen these dances myself. Chapman describes them from the Tena-Indians in Anvik on the Yukon to be, as he himself says and as I can confirm from information I received on the Kuskokwim, performed exactly in the manner of those of their Eskimo neighbours on the Kuskokwim. Chapman supposes that the Indians took them over from the Eskimos. He writes (page 19 sq):

I. The Otter Dance

The preparations began by laying down the insignia of the otters, a representation of a pond. This was made of two slender strips of spruce, each about ten feet long, upon which were inserted feathers, representing tufts of grass, and having sticks lashed across them which were shaved, so as to represent weeds.

Upon these were laid the three other masks, with the grass circlets, about three inches in diameter, and decorated with feathers, which were held in the hands of the dancers after the insignia had been raised and exhibited. These things were laid just behind the footlights. At each end of the insignia and in front of the footlights, were

placed the masks of the otter's messengers. No circlets were placed with these, the messengers dancing with gloves or with bare heads. The drums were struck and the dancers came forward and assumed their masks, kneeling with their backs to the spectators and making sounds in imitation of the otter. They continued in this position for a few moments, the song being taken up by the drummers and others, and the volume of sound gradually increasing. No words were distinguishable in any of the songs, yet some of them have words, whose meaning can doubtless be ascertained. The dancers soon arose and took up the insignia from the floor and held it in front of them turning their heads from side to side, swinging and swaying their bodies slightly as the chant went on.

Then they laid down the insignia, and took up the circlets, which they held during the remainder of the dance. The feet were not moved. The arms and bodies were moved in unison with the central mask. The chant changed from time to time, and new motives were introduced, but to the untrained eye there was but little variety. The two messengers, facing each other at each side of the group, danced in unison with the rest, and from time to time jumped up and down and gave the cry which is peculiar to them – The arrangement was as follows:

DRUMS
x x x x
OTTERS
x x x
INSIGNIA
FOOTLIGHTS
o o o o o o o
x MESSENGERS x

3. The Dance of the Silver Salmons and the Gulls

This dance was taken by a mask personating the thinking spirit of the Silver Salmon, with small figures of silver sal-

mon suspended in holes cut through the mask, and surrounding the face in the centre, of which is said to be that of the father of all the Silver Salmon tribe. This spirit is said to lead the tribe on its annual migration, going before the body to which it belongs, and which seems to be called its canoe. When the tribe reach the bad waters of the rivers, they leave their canoes on the bars and shores of the river and go by land over the mountains, to return next year.

The insignia are a wooden silver salmon and a wooden dog salmon. These are represented in a kind of cage, surrounding each, and symbolizing water. The large body of the silver salmon was hollowed out and the sides were pierced with holes, through which the light of a candle shone. The body was painted blue above and white below. The body of the dog salmon was much smaller, and was not painted, but a bit of candle was placed upon its back, where it set fire to the feathers with which the highly conventionalized water was decorated.

The central mask was supported on each side by a woman dancer. These women helped to hold up and exhibit the insignia. On the extreme wings were two white gull masks. These had as insignia the frames of dip nets, with small wooden fish depending from them. The insignia were 39 inches long, and were ornamented with feathers. The Silver Salmon spirit had his messengers also, who danced in the same place as the messengers in No. 1, making seven dancers in all in this number.

Ernest William Hawkes: "The Inviting-In Feast of the Alaskan Eskimo". 1913, p. 16:

Then a Unalaklit man took the floor and depicted the life of the walrus.

He wore a very life-like looking walrus mask, and enacted the features of the walrus hunt, modifying the usual gestures. In pantomime he showed the clumsy movements of the great animal moving over the ice, the hunter ap-

proaching, and his hasty plunge into the water, then the hunter paddling furiously after him, the harpoon thrust, and the struggles of the dying walrus.

Independent from earlier reports I have tried to establish the underlying concept for these masks. To influence a being inhabiting the animal is really the goal of the mask-dance. One painter: "In every animal and every plant and really in everything, oil-lamp or river or mountain, dwells a human-like being (Nunivak: Lechlgach, plural Lechlgat) which one occasionally is allowed to see." Lame Jacob: "A mink comes forward, and suddenly throws off his pelt and is a person." Many others say the same. On Nunivak, I learn that the same beings are evident in a shadow and in the mirror-reflection. Also men have a Lechlgach; it is their immortal being.

Among other things, one attributes to these "Little people" the power to make their species abundant, or if it concerns periodically appearing animals, to bring along many of their comrades. Lame Jacob's wife said: "Before we go berry-picking we always bury some food, for example fish, in the tundra. It is for the little men who live in the berries so that they will provide a rich harvest."

In order to convey this request in particularly lucid form, these souls were invited to the men's house. It is the task of the dances to please the invited shadows by having the animal represented in the mask and performances. Nelson writes on page 359: "The shadows of the various animals are invited and are supposed to be present and enjoy the songs and dances, with the food and drink offerings, given in their honour."

Accordingly, the dancers and the audience too feel the performance to be, above all, enjoyable entertainment. Only as an interlude does one enter into direct contact with the shadow. Suddenly the dancer calls out: "And now I want to dance for many seals

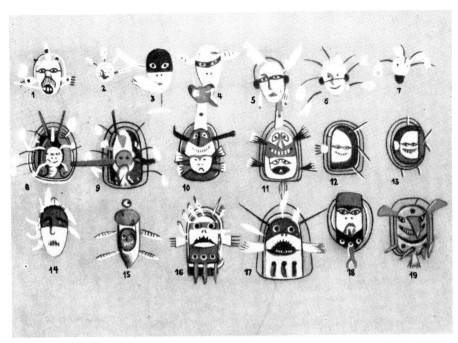

32 Masks from the Kuskokwim region of the Drebert-Collection: 4. White whale, 5. and 6. Men, 8. Mink, 10. Seal, 12. Fish, 16.–19. Seals

next year," if it is the dance of the seal, and then, "I am dancing so energetically to ask you to come in abundance next year" (Painter 'd'). Lame Jacob said one day: "Someone who wants fish, thinks and thinks while dancing, that the fish really might come, and says that he is thinking it. Those sitting around say: 'How nice of him to think of that.' — "But," he added thoughtfully, "sometimes no matter how much we dance, there are still no fish."

The masks represent (with exceptions noted further on) the faces of these animal-people, grotesque human faces on whose borders wooden representations of the limbs of the animal are attached: legs, tail, ears, wings, together with all kinds of carvings connected with the animal: the food that it eats, the ice holes through which the seals breathe.

The representation of the person within the animal is particularly evident in masks with two faces, one animal and one human. Either the human face is carved above or below the animal face (pl. 32, masks 10 and 11) or the human face is concealed behind the animal face (pl. 33). The latter can be flipped apart into two halves during the dance, as a hinged opening, and reveals behind it a human face (pl. 34). These masks are called Baduchdljuk = two-faces-in-one; simple masks are called Kinakok. Now and then the animal is presented with his entire body and somewhere on the body there is a human face. All these types are illustrated by Nelson.

Plant masks can also have faces: grass for mats, for example, are presented with high narrow faces because the grass is long, and all around it thin wooden spikes are attached to illustrate grass. As in this example, with the animal masks too an attempt is made to give the human face something of the expression of the accom-

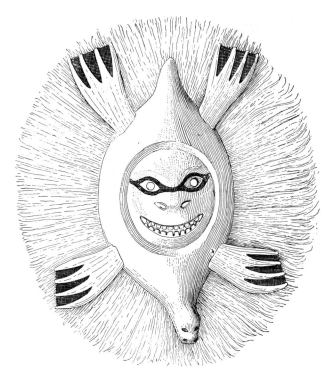

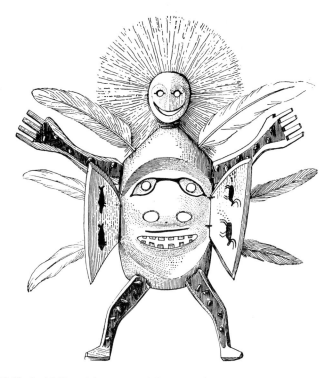

33 Mask of a seal, the "Inua" (Lechlgach) carved into its body (Nelson, 1899) 34 Mask with hinged door to reveal the "Inua" (Lechlgach) of the animal

panying animal. Mask 10 on plate 32 depicts the expression of the seal well (lower face), mask 11 (lower face) that of the codfish (compare pl. 68: a bowl picture of the same spirit), plate 35 a seal (above) with the human spirit which lives in him.

Further, the masks can be true-to-nature reproductions of animal faces without the grotesque human impact (plate 36). On the Togiak River south of the Kuskokwim estuary one dances, according to the missionary Schwabe (Bethel), with heavy wooden reproductions of the entire animal, which one holds in one's mouth by a pivot and shakes back and forth. Schwabe saw, for example, a wooden crane and a wooden, two feet long seal that the dancer, only through great labor, dripping with sweat, could keep in his mouth.

Charles can tell about masks which have movable limbs. They were hung from the ceiling and the limbs are made to flounder by means of a string, as with puppets. Petroff knew these masks (see page 131 of his report).

Now and then one finds fanciful masks: a shaman on Nunivak designed a fish mask for me as a large four-cornered piece of wood, with wavy lines across it which signified water, a fish painted therein and human arms and legs stuck into the rims of the board.

Hawkes, as well as Nelson, write about "totem" – masks, "totemic" dances (Hawkes, "Dance Festivals," page 17 – Nelson, page 395), but don't say what they mean by this totem and what the related dances are supposed to mean. In fact the Nunivak-Islanders have a concept of animal protective spirits, the Tschutschit. The shaman can reveal to a person that he stands under the protection of a particular animal, and there exists then quite a close relationship between the two, which finds expression in daily singing and offerings.

There is, however, no social arrangement tied up with it, nor is the Tschutschich inherited. The Tschutschich is the "Helper-spirit of the little man" (compare Dall, "Alaska", page 145), in contrast to the mighty helper-spirits of the shaman. However one denies vehemently on Nunivak that these beings are ever represented in masks. Since, however, as shown below, the shaman's helper spirits are represented in masks, it is entirely possible that the Tschutschit in St. Michael, where Hawkes and Nelson received their information, were portrayed likewise in masks. On Nunivak and on the Kuskokwim the animal masks are selected by the artists or the shaman according to the animals to be influenced, without regard to personal relationships.

The Actor's Masks

From Hawkes and Chapman come reports on masks based on personal observation. With masks, comical imita-

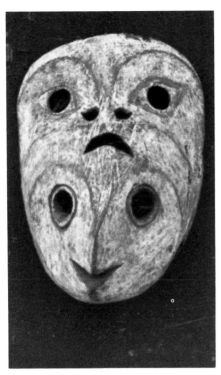

35 Double-faced mask

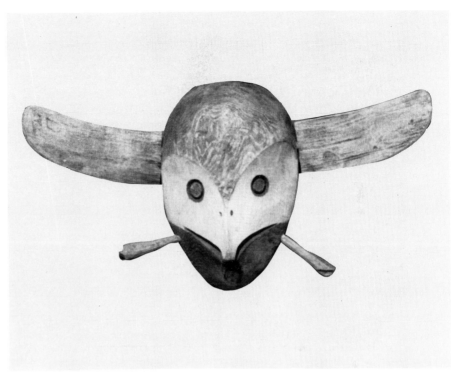

36 Bird mask from Kuskokwim

tions or performances of stories are presented. These also take place on the Kuskokwim. I will let Hawkes and Chapman report ("The 'Inviting-In' Feast", 1914, page 12 sq):

Comic Dances.

First Day. The dances the first day are of a comic character. If, during the day's dances, the home tribe can succeed in making the visitors laugh, they can ask of them anything they wish.

Entering the *kázgi,* I noticed that the walls and *ínlak* had been hung with white drilling *(katúktókūōwítklok),* as a gift to the visitors; who, in their turn, had covered the floor with *ūgruk* (bearded seal) skins. Shortly after, the people began to file in.

As each man entered he threw down a small gift before the *näskut,* as is customary on such occasions. As soon as every one was settled, the dances began. Strange noises were heard in the tunnel, gradually approaching the room. Then a horrible-looking wooden

face was thrust up through the entrance hole, worn by the chief comic dancer of the Unalit. The mask was made lop-sided, with one cheek higher than the other, and the mouth and eyebrows twisted to one side. One eyelet was round, the other in the shape of a half moon. A stubby moustache and beard of mink fur, and labrets of green beads, completed the ludicrous effect. He gazed around the audience in silence for a full minute, throwing the children into fits of mingled terror and delight. Then the leader commenced the dance invitation, and the pantomime began. Sitting in front of the hole, the actor gesticulated with his feather handlets after the usual manner of the Eskimo; occasionally turning his head from side to side with the foolish stare of a crazy person. But the Malemiut visitors, although their eyes twinkled, never cracked a smile.

Then he disappeared through the hole, coming up with a hideous green mask,

with a long nose, and a big red streak for a mouth. Surrounding the mask was a bristling bush of reindeer hair. He sat down solemnly, and all his motions were slow and sad. Every gesture, while keeping in perfect time with the music, expressed the profoundest dejection. As a serio-comic, this was even more funny than the other, and the Unalit, who could safely do so, fairly roared. But the cautious visitors sat as solemn as owls.

Then the Unalit trotted out their champion, a lithe old fellow, wonderfully graceful and impressive in his movements. He wore a mask adorned with feathers and an enormous nose, which I was told was a caricature of the Yukon Indian. The Eskimo have lost none of their old hatred for their former foes, and still term them in derision *inkilik,* "louse-eaters;" (Literally, "those having lice.") from the fact of their long hair being full of these pests. Neither is the Eskimo, with tonsured head, free from

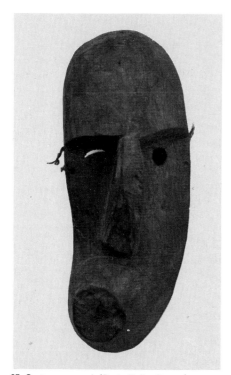

37 Grotesque mask (Portrait Jim Brown)

38 Trader Jim Brown

the same affliction; as I learned more than once, at a crowded dance, to my temporary affliction.

The old man took his place in the centre of the floor amid perfect silence. With head on his breast and hands at rest on his lap he seemed sunk in some deep reverie. Then he raised his hand to his head and cracked a louse audibly. This was too much for the Unalaklit, and they howled with laughter. Then, having won the day by this ruse, the old man began his dance. Two women with feather handlets stepped forth, and accompanied him, imitating his every move. Higher and higher he swung his hands, like the rapid upward wheel of a carrier pigeon. Then the dance stopped as abruptly as the others; the day was won.

The Betnelers once caricatured in a mask the trader Jim Brown who had an unfortunately crooked nose, to delight themselves at an Inviting-In Feast. The mask is now (1938) in the collection of Mrs. Heron (Bethel); B. is dead, and unfortunately I could get only a bad photograph of him. Still it can be recognized that in this mask there is a successful caricature (pl. 37); or rather, a portrait, for it is obvious, that trader Brown suffered from a paralyzed facial nerve. The mask more than his face shows all the characteristic symptoms: the twisted nose, the dislocated and half-closed left eye, the displaced mouth, and the reduced left cheek.

The Shaman Masks

They represent helper-spirits of the shamans, and are made by the shaman himself or – usually – by others upon his assignment, but are worn by him only on special occasion, and otherwise by good dancers.

I received the following information on Nunivak where the shamans have retained their knowledge as yet unadulterated by mission ideas. As helper spirits first, all Lechlgat are active, be they from animals, ponds, rivers, mountains or also from dead people; as such they are called Dunnerak. Secondly, the Ichzit, goblins, who live in the rocks by the bay. Occasionally one hears them stamping their feet on the ground, which provokes a long-lasting rumble in the rocks, a noise which one often really hears; probably it is made by thawing ice. The Ichzit often turn into animals, but their true form, in which one occasionally sees them, is human, with a face divided lengthwise into a human and an animal part.

Quite a number of these spirits appear to the shaman during the course of his life mostly in dreams and enlighten him because they have selected him as their friend and will now help him in the performing of supernatural duties. With their help the personal Lechlgach of the shaman travels to the ocean floor to take care of the consignment of large herds of walrusses, or it flies to the mainland to murder an enemy shaman.

Masks are made of these helper spirits. Their significance, as it was described to me on Nunivak, is quite strange and seems artificial at first, but corresponds exactly to the traditions connected with the masks. The mask-dance, as it is performed at the feast, is in fact not the sorcery act itself but only the figurative representation of an event that the shaman experienced in another world. If the shaman wants to meet his helper-spirits, he betakes himself to the men's house; some men sing and drum to him and, ducked under his rain-parka, he

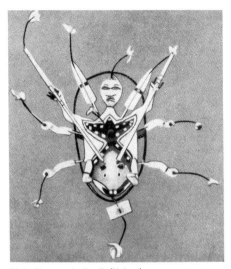

39 Indian mask, Anvik (Yukon)

puts himself into a state of complete peace which allows his Lechlgach to leave his body (since he apparently has no need at that moment for an active soul) and to proceed to the helper-spirits. These he finds in two different places: the Lechlgat or Dunnerat have a small men's house in the air, about half-way between earth and the residence of the sky-spirit, Chlamtshoa, and the Ichzit keep a men's house in the middle of Nunivak Island. There the spirit-meetings are held, and once the shaman's Lechlgach arrives there, he slips into his helper, for example, into a walrus, and they commence their trip united as a walrus.

Thus the shamans have the custom of boasting with the narratives of their adventures; they bring up their heroic deeds at every opportunity, and particularly if an unfamiliar villager comes to visit and the strangers are to be convinced of the power of the indigenous shaman. For such shamanistic propaganda compare Petroff, p. 162. After the dance of an animal mask during which the shaman handed an amulett to a hunter: "It was evidently unnecessary to look for any deep meaning in this performance, as it was only the shaman's advertisement of his charms and services pure and simple." Merely from this desire they have masks prepared by good carvers before the feast, which are supposed to represent Dunnerat or Ichzit, in or with which they claim to have accomplished this or that extraordinary deed. An Indian mask from Anvik (Yukon), plate 39 shows the shaman riding on an animal.

If one knows this meaning, one understands why the Eskimos even in mission-free territory assure one that the shaman masks are made only for the entertainment of the viewer. For that reason the shaman doesn't wear the mask himself, but leaves the exhibition thereof to someone else; for that reason, the animal represented is not imitated in the dances performed with such masks – it isn't an animal with animal qualities here, but a supernatural helper. And for that reason the shaman doesn't wear a mask for the actual summoning of the spirit. After all how would it be possible to carve a mask first in order to have a direct evil, for example, a storm, removed? There would not be enough time for that. Also, it would be nonsensical then to use the masks only at the Inviting-in Feast, that is not even held once a year.

However, performances have been seen north of the Kuskokwim in which the shaman himself put on a mask. Thus reports Hawkes of the Inviting-in Feast in St. Michael p. 17: "Then the shaman donned an *iñua* mask, and began running around the entrance hole in ever lessening circles. He finally tumbled over and lay in a trance, the while he was communing with the spirit-guests (so the Eskimo told me) in the fire-place below. After a time he came to and informed the hunters that the *iñua* had been pleased with the dances and promised their further protection for a successful season."

The Dunnerat masks have the various shapes of the animal masks, as they are used to influence the game, without any difference, or they are free inventions of the shaman, if they deal with Lechlgat of rivers, mountains or the like, which then are rendered as somehow distorted grotesque human faces. But – now I get another explanation for the masks with double faces: if it is a shaman mask, the human face does not represent that of the animal spirit, but that of the personal spirit of the shaman which has slipped into the animal. If it concerns a double-winged mask, and if the doors fly open during a dance to show the shaman spirit face, that means: the helper spirit likes his friend so well that he allows him to also show himself (Timothy).

The Ichzit masks are divided lengthwise into a human and an animal half, just the way Ichzits look; the one half of the mouth is thus human, the other animal. No specific animal is meant thereby. Ichzit masks are sometimes made very small, just about 20 centimetres in diameter and then are fastened over the eyes on the forehead. These small forehead-masks (Nunivak: Gnachtach) are the only art work which plays a small role at the great Feast of the Dead. They are carried by a few messengers: for what purpose was not made known to me.

The Dunnerat as well as the Ichzit masks carry around them an exterior circle of wood-carved appendages, which at first appears quite confusing but in reality is a very orderly arrangement: legs, heads, feathers, a kayak and other things. One can put these in order and might then get a seagull with wings, legs and a tail, and with it a seal with its flippers and so on. Those are the little helper spirits which accompany the shaman on his trip.

All these appendages are inserted into the edge of the mask, and held spread

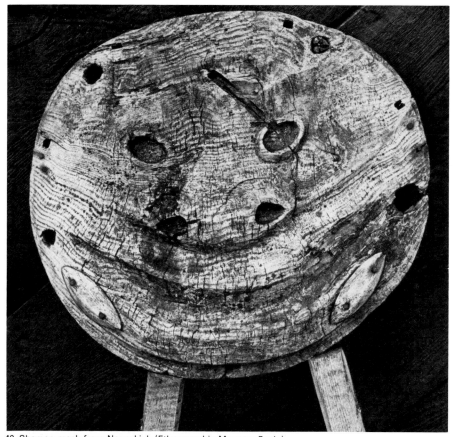

comes out and has no more than a slightly reddened skin. Charles added without having been asked, that it must certainly be true that these tricks are performed with the help of spirits, because a human could never do something like that alone.

I heard about another trick, in which a mask is used, and I found such a mask in the village Napaskiak on the roof of a hut and I bought it. It is now in the ethnographic museum in Basel. It is a big round piece with a broad grimace (pl. 40). On the back side is an oval hollow, apparently carved for the face of the wearer. The shaman lays this mask on the ground, face down. Then he requests five pelt-parkas from those standing around (whoever lends him his parka for the trick lives longer for it). He folds each and arranges them in layers on the back side of the mask, bends down, presses his face in the top-most pelt, gets up, and pelts as well as mask stick to his face. This trick was first described to me by a shaman in Bethel and then independently by Charles in exactly the same way. The latter added that one could also use a big rock instead of the mask.

40 Shaman mask from Napaskiak (Ethnographic Museum Basle)

out by two wooden rings which run concentrically around the mask. These two rings have a surprising meaning: the inner circle illustrates our world, the outer, the next one above us. All together there are five worlds lying above one another. No one could tell me why they wanted to show the worlds on the masks: perhaps, as said already, because the Dunnerat live in the air? Since, however, the rings serve a constructive function (they are also found on the animal masks), this meaning might have been superimposed on them later. The appendages themselves sometimes have symbolic significance: feathers, for example, can signify white-caps on waves (pl. 39).

Nelson further names masks which the shamans employ for that trick in which they let themselves be burned (page 434). The shamans on the Kuskokwim performed the burning trick, but without masks. Charles had witnessed it. The shaman puts on a rain-parka of seal intestine, goes into the fire and allows himself to be burned completely. Then all the onlookers retire to the men's house; the other shamans (apprentices) sing, and after a while the incinerated one reappears unscathed. Charles tells about yet another heat-trick. Into a big wooden tub filled with water hot stones are thrown until the water boils. Then the shaman puts his rain-parka on and climbs in. From time to time his apprentices poke pointed sticks therein "to see if he's done." After a while he

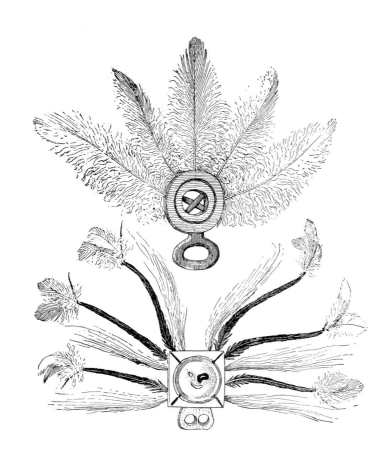

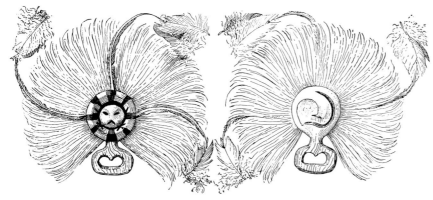

Dance Fans

During some of their dances the women carry a kind of fan in both hands, consisting of a row of feathers, which are stuck into the rim of a round piece of wood (pl. 41). The feathers are slit lengthwise and have plumage only on the ends, both of which makes them sway back and forth slowly with every hand movement of the dancer. The fan is held by two round rings carved of the same wooden piece. The dancer sticks two fingers through them. One must know that the women's dances also present happenings from the ancestors for example, a woman who was especially talented in preparing Akutak, the berry dish, but the performance consists only of very graceful, swinging arm movements which are barely decipherable for the uninitiated. It is precisely this flexibility that is valued, and this is supposed to be intensified by the swaying feathers.

Nelson's collection contains a set of these circlets whose circular is carved into a face. These faces have, as he describes, the same meaning that he gives for the masks. With the Kuskokwim Eskimos, in contrast to these, the fans are hardly artistic; they have only a few concentric, carved circles, each circle painted in a different colour. Lame Jacob explained that the latter had no significance.

Almost all following groups of sculpture are very simple representations. If the Southwest Eskimos were concerned with predominantly aesthetically oriented artistic exercises, these would hardly have a claim to be included here as works of art. But since, as described in the first section, what is of primary importance to the Kuskokwim Eskimo is representation, they must be discussed here.

41 Dance fans (after Nelson, 1899)

The Invitation Chain

Before village A invites village B to a Winter Festival, it secretly sends two old men to B by night. Arrived at B, these old men sneak into the men's house and seat themselves to the right and left of the entrance. When the sleepers awaken in the morning, they see the two messengers sitting there, and between them, held crosswise over the doorway, a cord, on which all kinds of wooden figures dangle. These represent, carved of thin timbers about an inch high, miniatures of the objects that village A would like to get from village B. Although the givers at the festival don't know who will receive their gift (everything is thrown onto one pile and then divided), specific people exchange gifts. Every man in A has an exchange-partner in B. If X from B brings a valuable gift to A, his partner there will give village B something equally fine. The two old men point to the figures on the chain and ask: "Who would like to give this mink pelt?" Someone volunteers. "And who this wolverine pelt, these shoes, the parka, the large spoon, the story knife, the mittens, the fur-hat, the bird-skin bathing cap, the kayak, the trousers, the spear, the otter pelt?" After everything is thus divided, the old men go back to A, and only then, after the gift-capacity of B is determined, are the real messengers sent with the invitation, young boys who are dressed from head to foot in new clothes by the hosts for this purpose (a few rich people appear again as hosts).

Exactly the same figures are carved for the small Request Festival, in which, as described on page 15, the men ask for particular objects from the women.

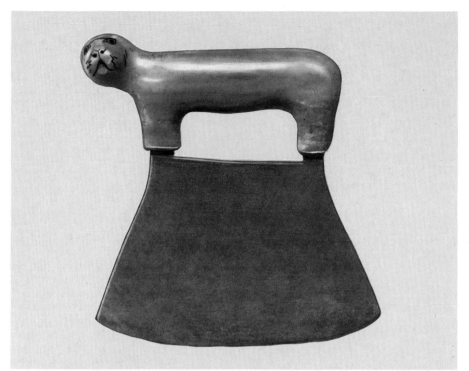

42 Ivory handle in the shape of a seal

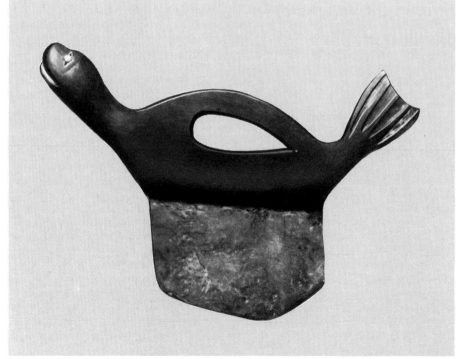

43 Scraper-handle in the form of a seal

Figures for Magical Purposes

While I collected numerous ivory figures of animals and humans north of Norton Sound to Point Barrow, which were made and sold by the shamans as means to a successful hunt (they were worn around the neck or placed in the front of the kayak), I didn't encounter a single such piece on the Kuskokwim. Some who were questioned affirmed their existence in earlier times, but in an unreliable manner; no one could describe their appearance or use, and most of them had never heard of them. However, Mrs. Heron in Bethel possessed a few ivory animal figures that seemed to be old and could have served such purposes, since they apparently weren't utilitarian objects. Perhaps the shamans made such pictures of the Tschutschit described on page 34, animal helper-spirits of humans. Jacobsen illustrates on page 347 a small human bone-figure and designates it as "Shaman's idol." I did, however, obtain a small number of ivory carvings for utilitarian purposes on Nunivak Island (pls. 44–48).

Ivoryfigures

Without exception these ivories are carved as animals. But even though the representations are made pretty and neat and the Nunivakers have developed a special style herein, only a few specific objects are honored with artistic form: the handles of sewing bags; the instruments with which the boot-soles get their creases in the front and back (so that they can be bent up); the spear-holders which are fastened in front of the kayak opening by a cord so that one can lay one's harpoon, paddle or spear on them; the socket pieces of the harpoons; and seldom the handle of the fish knife or the round ivory instrument that is used to pour liquids into the seal-skin, to hold the end open. On the whole island of Nunivak there were no more than three dozen such carvings. One can but wonder that such an obviously artistic talent does not seek a

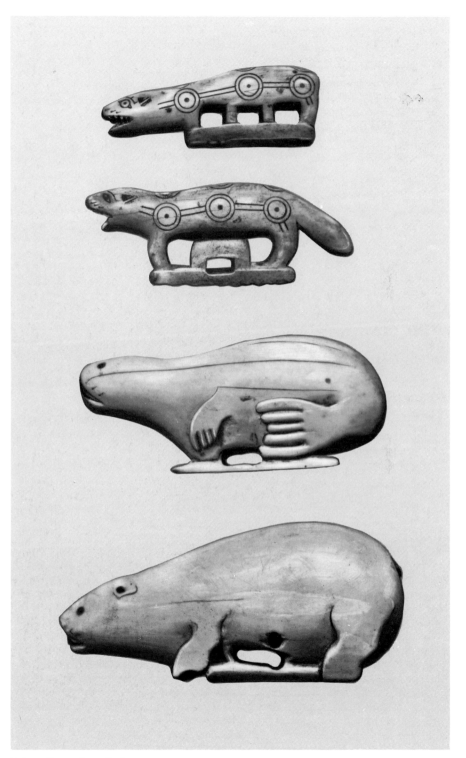

44 Ivory figures from Nunivak

41

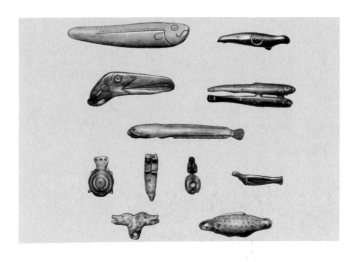

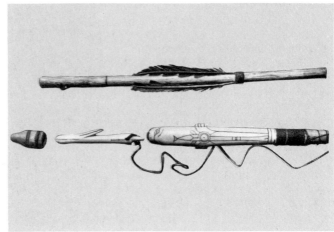

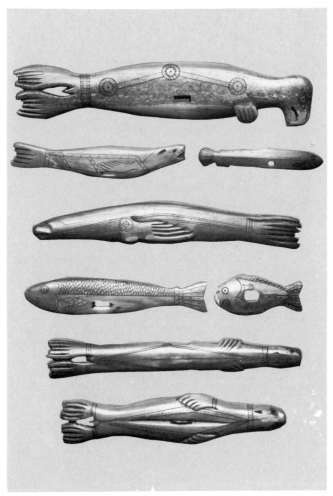

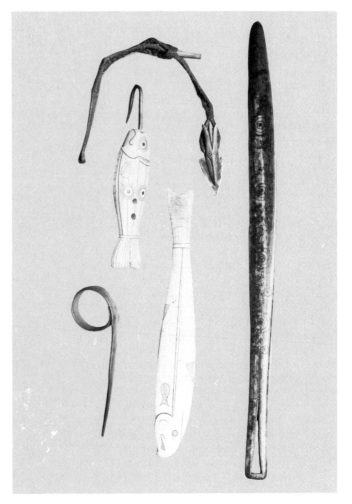

45–48 Ivory carvings from Nunivak

greater field of participation. Art in the aesthetic sense is unimportant to the Nunivakers.

One group of ivory figures has magical significance: animal figures are fastened to the wooden hunting-hats, so that these will fit tightly.

On the carved things, many animal features are incised in and smeared black. In addition, fanciful ornaments are drawn thereon, whose only significance is to fill the surface.

Toys

The only artistically fashioned toys are human dolls. There are no animal figures as toys. The dolls consist of a wooden or ivory head which is put in a parka, and sometimes the hands are also carved. Otherwise the latter are of fur, as if in mittens, and once I saw them made of bird claws. The little head is simple, but generally carefully made, especially if of ivory (pl. 50).

The small girls play with their dolls exactly as do white children. Lame Jacob said that on the coast entire families are carved, a father with his children, an uncle, a grandmother. The owner goes with these to a friend, lets her dolls visit the other's dolls, they change the clothes and so on. As Lame Jacob told me this, he added wisely: "Children are the same everywhere. Hardly are they a bit bigger so that they can observe things properly, then they want to have them, and their parents have to make them for them as toys. I tell you everything exactly so that you won't think the Eskimos are so strange. Ultimately people are probably the same everywhere."

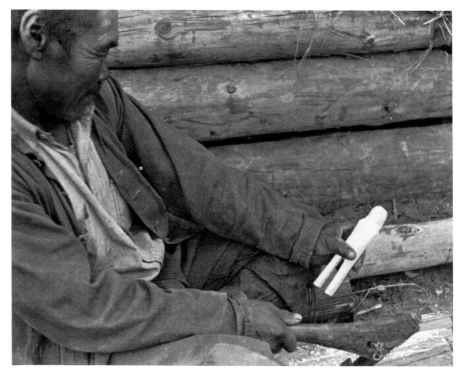
49 Carving a doll with an adze

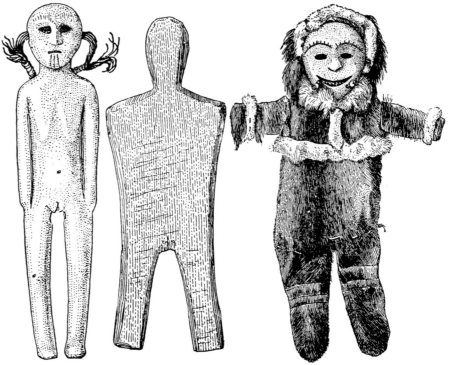
50 Dolls (after Nelson, 1899)

51 Face inside a kayak

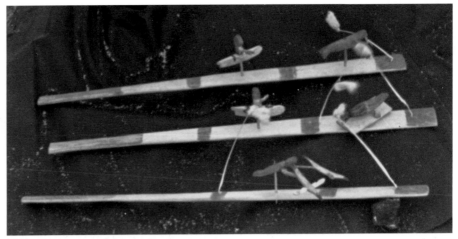

52 Three batons made by Lame Jacob

The Kayak Carvings

The frame of the kayak seat opening rests on two supports about ten centimetres wide, which are set there right and left where the arms of the paddler rest. On each of these boards, towards the paddler, a figure is carved (pl. 51). Both figures always form a pair, for instance a man's and a woman's face or a woman's breast on either side. These pairs are supposed since they are mutually supplementary, to hold the swaying kayak in balance. One has to know about kayak malices to appreciate just how desirable such supernatural help is (compare page 27).

These carvings are highly stylized. The face consists of only eyes, nostrils and mouth that are not even framed, and these features are no more than deep curvatures carved with a curved knife, and a woman's breast is no more than a circle with a dot in the middle.

Batons

At the family dances two or three conductors lead the rhythm for the drummers and singers. They sit in a particular place next to one another on the ground, facing the entrance, and move simultaneously a flat stick of wood about 80 centimetres long. They push away the sticks in a special rhythm and at the same time "hurl" their naked torsos after the stick. So it goes, hour after hour while the three are dripping with sweat and finally are completely exhausted. For these sticks an artist from the village carves small figures which represent scenes from adventures of a forefather, as described in detail under "Painting" page 16 ff. Plate 52 shows three batons which Lame Jacob made for me. The figures are quite simple, their limbs are, for example, just little sticks which look like pointed matches and which are stuck in the body and the staff. Nevertheless the artist shows a quite amusing imagination. Every stick has only one story, represented by two or three figures. Between the figures and on both ends slit, swaying feathers are stuck, like in the dance fans. Kusma told me that sometimes one paints the stories on the sticks instead of carving them in the same way as on the described drums. – These are the stories to three such batons:

1. The Swanflier (plate 52 below). Once a man was out hunting in the tundra. When he came to the beach of a lake he felt the urge to defecate. As he squatted there he saw two swans on the lake slowly swimming towards him. First he remained in this position but when the swans came closer he crept toward the beach and just when the swans rose into the air he grasped them by their legs. But instead of him holding the swans down, they took him up into the air. First he saw the green colour of the tundra below himself but then suddenly it was the sea. That frightened him. "How shall I return to earth" he thought, "perhaps the swans will go down way out in the sea!" Then he got the idea that perhaps one of the swans would not be able to carry him. He left one of them loose – and really the other one landed him softly on the ground. "Of course", Lame Jacob ended, "now he had only one swan and he had thought to catch two of them at the same time". Then he added: "In those old days the Eskimos were lighter and more supple – that's how such a thing could happen."

2. The Walrus (plate 52 above). Once there was a hunter who paddled among the icefloes in search of a walrus. He came to a point where he could overlook the ice – and really, there lay a wal-

44

rus! He thrust his harpoon and hit it at its flank. The wounded animal began to spit blood and each time when it vomited a red bag came out of its mouth. Until then he did not know that a walrus can have a maw like a ptarmigan. (On the carved walrus one can see the red bag between its tusks.)

3. The Red-headed Seal (plate 52 middle). Among the seals there is one species whose head and chest are red. But they are very hard to find – hardly anybody has ever seen them. This one on the baton was killed by a young man. He had heard many times that such seals did exist, but he had never really believed it. But when he was big enough to paddle a kayak, ambition overcame him to kill such a seal – if they really existed. And one day, after many many hunts he actually saw a seal with a red head and red chest deeply asleep on an ice-floe. (The little board on which the seal is fixed is the ice-floe.) The animal did not hear him and he speared it without difficulty. – This is an important story; because of it we know that such seals actually do exist. And what was strange is that this same man from then onwards frequently killed red seals whilst other hunters never even saw one. They used to stand and look at the strange animal when once again he had killed one and couldn't understand it. The hunter however became so conceited with his success that he no longer called his relatives by their titles – uncle, grandmother – but shouted: ''Come here my ziusvik – my red seal.''

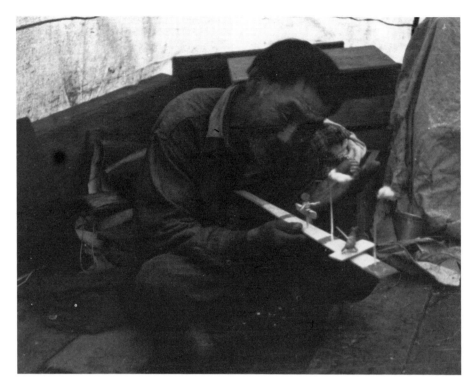

53 Lame Jacob playing with a baton

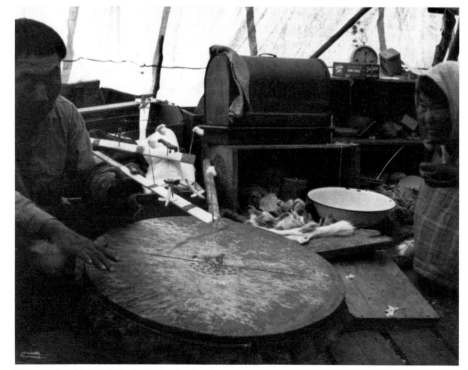

54 Lame Jacob's wife listening to her husband

55 Graveyard in the Kuskokwim region

Grave Figures

The Kuskokwim Eskimos bury their dead above ground in coffins of heavy planks which are placed on stakes, because the earth is eternally frozen in low depths. They still remember, though, that they used to simply carry their dead to the tundra and leave them there. An intermediate form is found on Nunivak where the dead were surrounded and covered with large stones until a few decades ago; then coffins were introduced. All the Eskimos say that coffins were an Eskimo invention and not instigated by the whites. Along with the coffins, one finds on the Kuskokwim wooden grave posts about two metres high of three types: a strong post whose upper end is carved into a face and in whose sides two arms are stuck (pl. 55) — or secondly, a wooden face pegged to a large board with a half-round roof-board over it (pl. 58); sometimes two or three faces are found beneath the same roof for members of the same family — thirdly, posts with wooden animals stuck on them (pl. 59). Usually the figures are painted red, with eyes and mouth of ivory. The purpose of the figures is exclusively to mark the grave, as I was told; but Nelson heard of type three that it was erected to make the shadow of the dead aware of the impending Festival of the Dead.

According to Andrewska, the erection of the grave post is done nowadays by following specific rules. About a year after the death of a member, the family holds a feast to which they invite all the men, or in the case of a dead woman, women of the same generation.

The food divided at the feast and consumed by the guests is supposed to feed the dead. (Compare Knud Rasmussen "Intellectual Culture of the Igloolik Eskimos." Report of the fifth Thule Expedition, 1921–24, VII, No. 1, p. 198 sq, cit after Weyer: "After a death among the Igloolik Eskimos, those who carried the corpse, after returning to

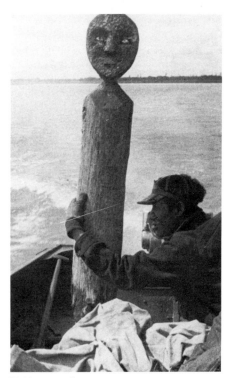

56 Mortuary pile

the dwelling, must each drink water from the dead person's cup, so that he may have a drink.") At the end, every guest receives a small but new gift.

Already before the invitation, the close male relatives have carved the grave-post together. During the feast then, it is erected next to the grave, as I was told, "so that it will always be known where the dead one is lying." It has human features, but these are not meant as a portrait. It is just supposed to be a dead person, not the person concerned. Only with regard to the sex of the person does one take heed in the fashioning of the facial-features as described on page 14. Otherwise one figure looks like the next, but the creators know their work from the others anyway, and thus the grave is marked correctly. An Eskimo told me that before the arrival of the whites they used to put the parkas of the dead on the grave-post. That would naturally have identified the figure quite clearly and may be the reason that not more care was taken with the face. That would also explain why the torso of the figure is always unworked.

The property of the dead is pegged to the mortuary piles: the hunting gear of a man (his kayak and sled are always put there on Nunivak), the toys of a child, the teakettle, fish knife, wooden vessel of a woman. Sometimes such a post exhibits a veritable museum collection. On the board type the colorful bead caps (for the dances) and the bead necklaces of the women always hang underneath the faces. Usually the board monuments stand a bit on a slant because one of the supporting posts has rotted away, and thus they look like an alpine votive board with paper flowers, there on their grassy hill.

The two types with human faces, the post type and the board type, are found all along the Kuskokwim but never both in the same village. A difference in the meaning does not exist and I couldn't determine how the two types came about for the same purpose. However,

57 Grave with two wooden faces, near Bethel

58 Grave with a face under a half-rounded roof, near Bethel

47

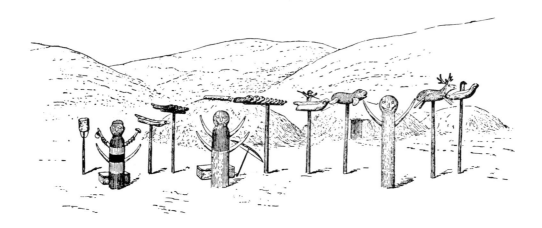

59 Grave posts with animal figures at Cape Vancouver (after Nelson, 1899)

Gordon illustrates on page 131, a figure-gravepost, whose head stands under such a roof. Probably the facetype with roof was derived from here; the post-type would thus be the original form.

In addition, there are the animal posts, which today have disappeared from the upper river, but were said to have been just as abundant there, as until recently on the coast (illustration in Nelson, page 317). An entire forest of such posts stood, as I was told, in the cemetery of Tanunak on Nelson Island. This unique monument was destroyed by the white teacher, "because he did not like its looks."

These animal grave posts stood in the cemeteries on the Kuskokwim between the posts of the mentioned kinds. Their significance was thus explained to me: if a dead person was not very well liked, so that one didn't always want to be reminded of him through the figure, an animal was carved for his gravepost, in the hunting of which he was particularly successful – right after the burial (Andrevska. Compare also Dall, "Alaska," page 146). I leave the matter undecided whether this explanation corresponds to the original significance. Zagoskin reports that earlier the skulls of the animals most hunted by the deceased were laid on the coffin; perhaps the animal posts came into existence in this way, and then for the especially beloved relatives, the human posts. Further, an Eskimo told me that often the picture of the best-hunted animal was painted onto the face of the figure, and Nick Buluktuk said it was painted in red beneath the face on the post. Hrdlicka illustrates an Indian coffin from the Inoko River (somewhat further to the east) which is painted with a beautiful deer procession ("Exploration and Fieldwork" Washington, 1930) and in his "Anthropological Survey in Alaska" he shows an Indian coffin with the picture of a white whale, "of one who was a whale hunter." Jacobsen saw among the Yukon Eskimos a monument upon which "a bear was painted, which had been hit by an arrow." (Woldt, page 211). Nelson speaks several times in connection with the grave figures of the coastal area about representations of the totem animal of the dead ones, (without further explanation), in contrast to representations of the best-hunted animal which are also known to him.

Unfortunately the Kuskokwim Eskimos do not take care of their graves and grave figures, so that no old types can be seen. They allow the post to decay and rot in the tall grass which the mouldering corpse always allows to grow around it. The disregard for the graves is all the more striking since one is usually very touchy in matters of the dead. The latter is easily explained: the dead are really still here, they are simply lying next to the village in their coffins, so that one always sees them.

48

Talent

Who has Talent?

The execution of the individual plastic and graphic arts is divided between the two sexes; the women illustrate stories, design the fur clothes, the men carve and paint. A man never practices a woman's art, nor does a woman carve or paint. This is a custom, tradition, not due to aptitude. A boy passes time in archery or idleness – if one should suggest that he draw a story, he would be as indignant as a white boy to whom one would wish to learn crocheting. A woman does not paint because she is not allowed to. As Lame Jacob painted his family mark for me, his wife described to me exactly the way her mark looks: two whales with large moustaches, all the way around the bowl. I asked Lame Jacob if he would let his wife paint her mark for me, and I saw how Mrs. Jacob's eyes gleamed at this suggestion. She would have loved to do it! But, "I wouldn't like to," said Lame Jacob in quite a friendly manner, "because it is against the dignity of the man if a woman paints. I would like to reserve that for myself. If we want the women to do something like that, we will let them sew it onto the clothes." (see page 24).

Nelson disputes the artistic talent of Eskimo women. He did, indeed, see the children "do fantastic figures on the snow", but story-drawing itself escaped him, and in another place he writes (page 197): "...the artistic skill appearing to be confined to the men." A look at the girls' drawings, however, shows artistic talent at least equal to the men's drum-painting. The quick progess of the plot and the thereto connected changing of the drawings necessitates a speedy jotting down of the motif's characteristics: if the grandmother is represented with the grandchild, the child will consist of a large trapezoid for the torso wrapped up in fur clothing, and two small triangles below for the legs in heavy fur boots. The grandmother is reproduced as no more than a trapezoid, "Because old women always pull their fur clothes over their legs to keep warm when they're sitting." Thus, story-drawing may not at all be compared with something like the building of snow-men. Likewise, the drawings of the girls give evidence of talent in the government schools. The intelligence of Eskimo children was recently tested by Anderson, Dewey, Eells (page 314 of their book) through the Goodenough Test, in which capability was determined by the exactitude with which a human figure could be reproduced. The girls fared better than the boys.

Compared to these, the women of the Baule-people of West Africa studied by me seem artistically ungifted. They are dedicated to the pottery trade, but no matter how much trouble they take to make their work attractive, since they do want to sell it on the market, they don't succeed in making more than just agreeable forms out of the easily molded material – three or four repetitive types – and these with timid dot and line ornamentation, whereas the men create the well-known art works of difficult-to-work metal and hard wood. "The women are too dumb and too lazy to accomplish respectable handicraft," say the Baule-men.

With the Eskimos, on the other hand, the weight of handicraft work is commonly on the side of the women: it is they who make the clothes, the boots, they weave mats and baskets, all of which is men's work among the Baule. Certainly the Eskimo women are at least as intelligent as the men. They are in their entire standard of life of stronger character and more respectable personalities than the men. They aren't idle and are almost always doing harder work, don't allow themselves to get old quite so rapidly as the men do, who complain at every opportunity that they are already so old and feeble. Hence, the married woman in her igloo is "the spokesman" and can leave her husband whenever it may suit her – she simply stops sending him food to the men's house, and he well knows what that means. On Nunivak I was told: "A husband must be pretty nice to his wife, in order to keep her."

All girls draw with the story knife, nearly all men paint and carve. In the results, however, quite clear levels can be distinguished, which indicate that the practice of the faculty alone does not mark an artist. One carves and paints primarily to represent something. This desire alone "justifies" such activity. The acquisition of technique is no hindrance: every Eskimo must carve to a certain degree, regardless of ability, because countless objects of daily utility derive from this technique – bow and arrows, shafts for spears and harpoons, fire-drills. Even spoons and bowls are made by everyone. Kayak construction, on the other hand, is the work of specialists. The case is different with painting and drawing; no vital functional objects derive from these. But drawing with a knife or painting to achieve a modest representation is so simple, that no one is frightened to practice the technique. Thus, the true artists must be recognized not by the practice itself, but only by the results of their work.

With drawing that is difficult. Differences in quality barely exist. Here it isn't an "art" to reproduce a recognizable motif, in the large-lined, hurried style which characterizes knife drawing. Anyone can draw a "kayak on its rack."

Artists among the girls are only those who know how to fashion difficult motifs, for example the "girl on a river between two mountains" (pl. 29). Here a solution must be found as, perspective representation unknown; the features of the picture which are important for the narrative – the mountains as well as the river and the girl – are depicted with deviations from nature.

The observed draughtsman is usually not the creator of the representation form. The story illustrations are repeated so often that the girls can watch and copy the creations of the gifted draughtsman without using their own imagination and creativity. Every girl can draw a "grandmother in the igloo" because it is seen so often.

One must catch a girl at sketching if one wishes to get to know a real artist. That is not difficult, since sketching itself is one of the favourite pastimes. One often sees a group of girls lying around one or two draughtsmen who are not, however, telling a story, but simply experimenting. In Kukok I once observed a child who, in front of her peers, had drawn a large face on the ground and now was experimenting how to draw a nose: she tried and tried and kept erasing it as unsatisfactory; at first simply two circles for the nostrils, and nothing else; then a triangle down from the eyes, then two converging lines down from the cheeks, and finally she was satisfied with two circles with an arc over them – a very unclever solution.

In the case of the plastic arts, the levels from artisan to artist are easier to recognize. Here, talent can be deduced from the finished product: the grave figures are almost always awkward looking – one learns that they were carved by a couple of family members of the dead one, who need not understand the art of carving. An elite shows themselves more readily in the matter of doll-heads. The uncle, who knows how to carve them "as they are in reality", receives the preferential requests for them. These would be the artisans. The true creators are the mask-carvers who understand how to reproduce a specific animal head with a few large plains.

All degrees of quality are found in drum painting. He who cannot do better may paint twenty lines in a circle for the twenty minks which his grandfather found in his fish cache. If he is bolder, he also paints the grandfather, and if the latter is blotchy, that isn't really so bad; the merit lies primarily in the story at the bottom of it. Here is the view which is the counterpart to the art-for-art's-sake-idea: representation for the sake of representation.

If, however, one can make this representation beautiful, it is thus a very welcome bargain. People who know how to do this are famous; they are called tst'rejuli = a man who can draw a line well. The name is indicative: beautiful above all is the animated line, the symmetrical contour. The flipper of the seal is consistently improved until it is very smoothly proportioned. That holds equally true for sculpture: the apparently simple bowls are in reality carefully made with an eye for line, and in that respect may count as works of art; the indentations in the rim, the round corners and the base must be entirely symmetrical. Otherwise the artist is simply not satisfied. He gives it to his neighbour for endorsing and improving. This superior capability is valued as are the art works which it produces. It may even go so far that the ungifted prefer, instead of bungling, to let such an artisan paint the family stories on drums for remuneration. Still more frequently one has one's family marks painted on bowls by others, because their longer endurance lays a special premium on artistic quality. Sometimes an ungifted one, like Betka, practices his mark as long as it takes him to be able to paint it by himself.

With all branches of art, talent may be recognized by the method of working as well as by the finished product. The notes which I took during the observations, are full of such situations. With Sando I wrote: "I am trying to see if Sando really has an artist's hand or if he just works with a learned routine. Finally the speed and sureness of his thousand cuttings convinced me that he surpassed simple exercise in his quite clearly creative conception." With John Boss it was "wonderful to watch how he now with a true artist's hand conjures up the bird (pl. 60); starting at the beak, he moves with one stroke to the end of the tail, a small arc for the underside of the body, two fine lines for the legs – there sits the snipe." Even more clearly does individual talent appear when one puts two artists to work with the same task. Differences in the dexterity of creating show themselves clearly with Zigeb and Alexi, with Andrew and William. Zigeb and William are inferior to their comrades: it simply doesn't come out as well (see pl. 62).

But all mask carvers are essentially unfailing. They chop away at the mask-block with a large adze without stopping or considering once not until the mask already shows the facial features, only then do they resort to a finer instrument, the knife. And it is an experience in itself to witness with what ease the resulting animal portraits come into existence without models, with what certainty the imagined face is carved of the wood, without trial, without preliminary drawing.

However, among the mask carvers one discovers a very peculiar fact: the frequent personal separation of the conception and the execution of the artwork. As emerges from the statements about masks in the second section, a portion of the masks represent the helper spirits of the shaman, as he has seen them on his flights or in dreams. Since, however, as Kusma said, the shaman doesn't have the patience and often not the talent to carve masks himself, "he just thinks about it and then chooses clever people for the task." But he sits nearby and watches that it be done properly. Nick Buluktuk said: "The shaman prescribes everything ex-

actly, goes from one carver to the other in the men's house and improves on what they're doing according to his idea." Kusma explained: "When I was a young boy, we made some play-masks for fun, but when I grew older, the shaman ordered masks from me. I first had to chip the block from scratch, then he came and drew with charcoal on it how the mask was supposed to be. He had it in his head." (The dancer doesn't have to be identical with the carver.)

It is difficult to say how many real artists there are in general in a normal village of about a hundred to a hundred-and-fifty Eskimos because the mission has greatly restricted the ceremonies and with them the art-practice on the Kuskokwim, and Nunivak with its mere 215 inhabitants does not allow any generally valid confirmation. It seems as though one carves more commonly upriver, not because there is more talent, but quite to the contrary, because the pretensions are fewer, the masks are simpler, the drum paintings less imaginative – one paints, for example, no intestines in the animals as in the coastal area (see page 80). Vasil, in Napaskiak, who comes from Kipnuk on the coast, explained: "Only a few people on the coast can make masks." Vasil from Jestlands Post, also from the coast, told me: "Long ago everyone could carve wooden bowls, but not masks." Zigeb, on the other hand, from Tuluksak above Bethel on the Kuskokwim, maintained: "Anyone can make masks." When I asked Ivan in Kwethluk above Bethel if he could carve me a mask, somebody said: "Naturally, since he is one who still remembers the old times from his own experience." I would like to assume that a village of the aforementioned size on the Kuskokwim estuary and the connecting coast has about 10 mask carvers.

Generally the rule holds true that mask carving is more difficult than drum painting. In my search for artists I have found that there are about twice as many real painters upriver from Bethel

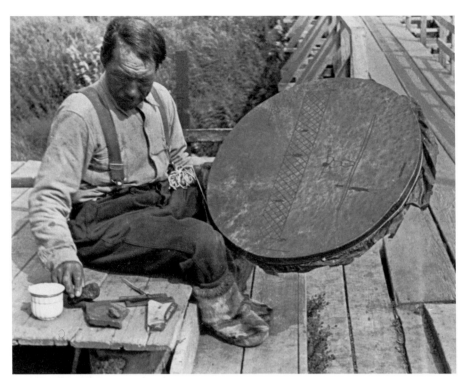

60 John Boss preparing utensils to paint

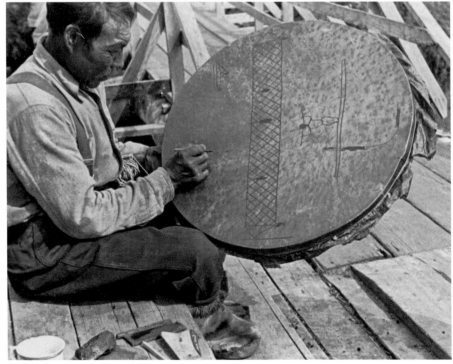

61 John Boss painting the third kayak onto his drum

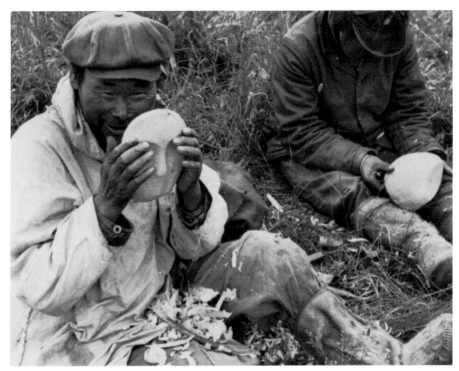

62 Mask carvers William and Andrew

as mask carvers. Most of the carvers are simultaneously good painters. – How many story illustrators there are among the girls, I cannot say.

Again the disintegration of Eskimo art through the white customers becomes evident. In St. Michael, Charly Coffee and Sando said: "Ivory carving? There is nothing to it. Anyone can learn it." One can't imagine how low the demands of the white inhabitants and travellers are in general. Their taste could really be satisfied by any clumsy child's hand.

The Manifestation of Talent

Questioning the Atutu and Guro artists in West Africa showed that one should not assume that an artistic talent will manifest itself for the sake of its own gratification. The carvers there consider their activity a difficult, tedious task which they learn and practice only to earn a living. Hence I wanted to determine under what circumstances and from what motivation the talent of the Eskimos manifests itself.

I asked the artists how they learned to practice their art. Not one of them had an answer to this question. Children do not produce art works for their own desires, apart from the drawings, which are really only done by children; these they copy from each other.

Only Kusma said that as boys they carved themselves masks to play with. Otherwise, he said, it is as follows with painting and carving: if one is half-grown and loitering about the men's

house, one would probably see at some time an older man painting a drum, and would naturally watch, and finally would try to do ones own family mark. The latter seems always to be the beginning. In the first night of the Bladder Festival on Nunivak I watched several boys whose fathers had carved them small bowls so that they could paint their marks on them themselves like grown men, which they did with great devotion, but with very imperfect results. Or the father might say one day: "Come here, I want to show you how pictures are painted" (Lame Jacob). But coercion or formal lessons do not exist as in Africa. Charles: "The older ones watch the young ones paint and say: 'Put the bird there; it looks better that way.'" Lame Jacob: "At first it isn't so good. But one sticks to it and says: 'Oh well, that's nothing special, but next time ...' and so it gets better with time." Lame Jacob's wife added: "When he was young he always sat by the old ones and listened to their conversations," she lowered her eyes, "and because of that, I think, he now is so clever." "If someone can't paint, that's his own misfortune; no one else cares about it," said Kusma. With the ivory-carvers working for the stores on Norton Sound the case is different: Sando said that nowadays the fathers often induce their sons to learn this profitable handicraft. Charly Coffee bluntly said that he learned carving "only to earn money." – With the traditional Eskimo artists, there is, then, no external coercion to learn the handicraft, and thus one would like to suppose that those who take it up permanently feel an inner impulse for it.

But: I asked the artist why he carved or painted for the first time on his own. It became evident that the first, as all the later works of art, derives from motives outside of the drive for artistic creativity: masks, because the shaman commissions someone to do them or because someone wishes to represent an animal in the dance; drums, to bring a

story to the listener. Only the small girls who draw illustrations into the mud out of sheer creative-pleasure again constitute an impressive exception.

Never does a piece of sculpture or a painting, thus, derive from a pure desire for creating. No motif "fascinates" the artist. It doesn't happen that someone paints a drum in the summer for the Winter Festival because he has a particularly good idea which moves him to express it. Masks, as drums and dancing staffs, come into existence only shortly before "use" in a "Christmas spirit" engendered by the approaching festival.

Just as infrequently is a work produced for the pleasure which the creation affords the artist. That is all the more peculiar since, as shown in the first section, the Kuskokwim Eskimos have so much free time which they idle away in the men's house. Why doesn't the artist take a block of wood, a piece of ivory or his paints and carve or paint out of sheer creative pleasure? Jack was an exception. He was just going fishing when he saw me sitting with Sando. He came up to me of his own accord and offered to carve a mask in front of me without knowing if he would be compensated for it, got a block and eagerly went to work. When he was finished, he beamed, held the mask up and was pleased with the successful portrait. Questioned later, he said: "I carve only because I like to." However, one should not conclude from the fact that pleasure to create is not the origin of creation, that the artist, once at work, does not enjoy fashioning his work. One need just ask him.

He will answer that it was surely a pleasure, even if carving as such is disagreeable and so tedious, so that one usually doesn't carve masks unless they are needed. Kusma said: "Eventually each man must work as long as he is young. But it's true, there are many people – like Lame Jacob – who like to carve." And Lame Jacob himself explained: "Sometimes when I have no

other work, I carve something for the children." Ivan I cautiously remarked: "Sometimes I like to do it, sometimes I don't."

On the other hand, painting is fun, as a matter of course, because it is easy work, in which there are no time-consuming, unpleasurable unwrought stages to overcome as there are in carving. Just because it is a pleasure, bowl-painting is saved for the Bladder Festival. It was easy to find painters. They volunteered often without persistence on my part, even before they knew that they'd get tabacco and chewing gum for it. Alone Kusma again perceived work in it. When I approached him for the first time for a demonstration, he said: "I don't feel like painting right now." I: "Just what *do* you feel like doing?" He: "Feeding my dogs." But he did paint then and became one of my most fruitful painters. Charles said he used to be happy about painting long before the festival but now he was just old. John Boss gave exactly the same answer previously.

Their joy for working can be seen. They don't pause and they work with eager seriousness. Once the painters are sitting over their walrus-gut, the pictures just pour out. Again and again they thought of one more thing that they had to show me.

In no case does the difficulty of the work frighten the artist as in Africa. The "much thinking" involved was so tedious to the African carvers that they said: "One must constantly think whether it will be right this way or that, and afterwards it is wrong anyway." On the contrary, the Eskimo artists have a very untroubled, aggressive relationship to their subjects. I asked Andrew and William what kinds of animal masks they wanted to carve for me. "Every kind," they answered. As a matter of fact, the painters have a lot of fun complying with my wishes when I'm investigating how they represent unfamiliar things. I asked Kusma for a spruce. He had never painted one, but put himself

directly to it and from there proceeded on his own to paint a birch.

The talent of the Eskimo artist is, in general, neither inhibited through external details – instruction, connection with another occupation – nor through internal restrictions (awkwardness in thinking, fear of innovations). Where it manifests itself, it does so with much freedom and easiness. Nevertheless, the artist does not work for the sake of gratifying his talent. We confirm the specific fact that talent can exist without the impulse to manifest itself.

The Estimation of Talent

Like the Atutu-Baule and Guro people in Africa, the Kuskokwim Eskimos see no more than handicraft skill in artistic ability. When I asked a mask carver what he could carve besides masks, he said: snow-shovels. Mask carving is classed next to the carving done in kayak construction but above bowl carving.

Thus the artist enjoys no particular recognition for his ability. He is valued decidedly less than other artisans, hunters, boat builders, because from his hand no utilitarian objects derive and because art itself takes up such a narrow space in the Eskimo cultural content. Therefore the esteem of the artist is barely graduated. There are no artists, who, as in West Africa, become famous because of special achievements. One does not say, as with the Atutu: "That is the artist who always makes these particular masks." Carvers who work for the stores are not esteemed at all – the old ones say "that is nothing at all."

Nonetheless, interest in the work of artists itself exists. We always had numerous viewers at our sittings, who weren't at all interested in my writing, but in the artworks taking shape. Sometimes during the observations of mask carvers I saw young boys who stayed around the artist the entire day until the mask was

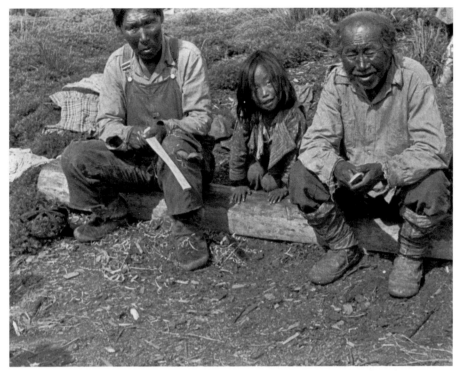

63 The carvers Nick Buluktuk and Jimmy Lomak

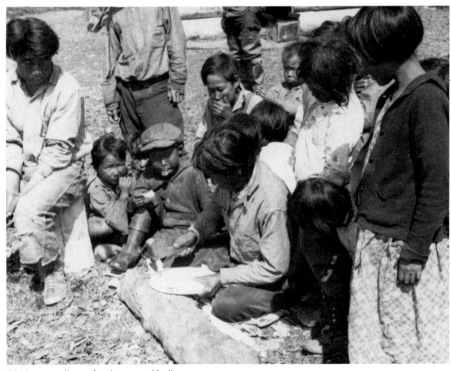

64 Young audience for the carver Vasil

65 Drummer by Kusma

66 The artist Lame Jacob

The Practice of Artistic Activity

If not much significance is attached to either the talent or the product (see section 1), no fixed handicraft customs can develop. The artists form no groups, alliances, hold no conferences, have no insignia, profane or religious customs, and one keeps no secrets. It is not even considered necessary to bring the learning into a system, a doctrine. In brief, for the Eskimos there is no concept at all of the artist as an outstanding person who is important for the community.

There are no complicated forms of workmanship: no specialization, no division of labor. Whoever can paint, paints drums and family marks; whoever can carve masks, also carves dollheads and dance-staffs. Just as seldom does one restrict oneself to specific mask-types. The only instance of division of labor occurs in the making of dolls: the men carve the heads and

hands, the women make the bodies, legs and arms for them of fur. They don't divide the work into carving and colouring the masks, which would be a natural arrangement considering the extensive production before the festivals. Only with the artistically unimportant grave-figures do several relatives of the dead one help. And on Nunivak I saw, on the first night of the Bladder Festival during which all men paint their marks onto the new bowls, that occasionally someone exchanged his half-finished painting for that of someone else and continued working on the other one, because they are of the opinion that two discover more errors than one. They do the same with regard to the carving of bowls, in which very great value is placed on symmetrical, graceful curves.

Usually the artist works for others without compensation for his labor, thus always when the general public is the customer, in other words, in the manu-

facture of masks for the festivals. Dolls and story knives he gives to the children who ask him for them, and earrings to his girlfriend. But if someone wants a drum painted to show off at the festival, then he should pay something for it, and likewise, if someone would like to have a "grandmother" painted on his kayak (see page 27). Peter said: "If someone has carved a bowl, he sometimes brings it to me so that I'll paint his mark in it, and then he gives me something for it. One doesn't do something for nothing." Vasil (Napaskiak) used to get an annual assignment for masks from the shaman and was paid for it. They don't set a price, however; the customer brings something after the completion of the art work "just to show his appreciation." "It is never too little," said Vasil. "Fish are brought, and for smaller things, prepared meals."

Art objects do not constitute trade goods (this, also, in contrast to the African situation). Whereas other goods

55

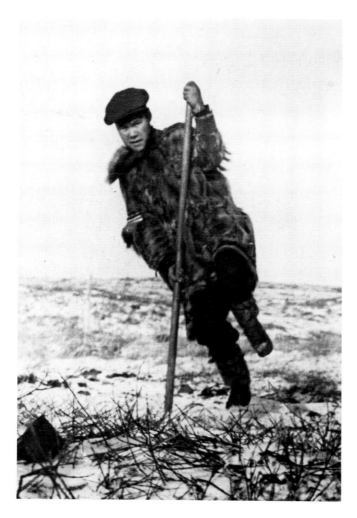

67 The painter Timothy

are traded from village to village and region to region, masks and ivory carvings are never bought from another village.

Annually the Nunivak islanders come to the mainland and ride up the Kuskokwim to Akiachak, in order to trade deerskins for seal-oil. They bring material for art works, ivory and paint, but never finished art-objects, or bowls, for which they have a certain reputation.

The Personality of the Artist

I have attempted to recognize a specific character-type in the artistic people, but I didn't succeed at all. It might be said that on the whole the artists are simultaneously the most intelligent people in the village and show no sign of emotional temperament. None of the artists was a loafer (of which there are many around), but were, far more, people who appeared otherwise as diligent, active, and industrious. Four of the artists had serious physical injuries which hindered them greatly from doing other types of work: Lame Jacob, Sando, William and Timothy. All four of them had great difficulty in walking because of lameness.

Nowadays most of the artists are old men, because the young ones are more strongly under mission influence. Earlier, however, it was precisely the young lads who were the best mask carvers. Mask carving was, in part, men's house service to which one could be ordered by the shaman, if one had once proved one's skill; the old ones studiously avoided it. Kusma said that the shaman picked out young, unmarried lads for this; unless he commissioned his own shaman-apprentices to carve – in which case they had to be married. Thus the picture of the artist personality, as one gets it today, is somewhat distorted; the majority of those who carved and painted for me were old people.

Only when Eskimo artists are compared to those of the Atutu-Baule does the artist's personality emerge more clearly. The Eskimo artists are much more certain of their skill. They don't hesitate to show their art, they firmly propose what they want to make. They are more serious and steadfast at their work. If I wasn't questioning them, they didn't bother about me or anyone else while at work. If I had two artists work for me at the same time, they usually turned their backs to one another and didn't speak. Once begun, the work was finished by the end of the day, whereas some of the African artists observed carved around on a mask for weeks because in between they lost their enthusiasm. They often worked on several pieces at the same time, which an Eskimo artist would never do.

The most pronounced artist types in this sense were Lame Jacob and John Boss, then Charles and Kusma.

With all the questioned artists the talent was inherited from father to son, although, as shown on page 52, there is not the slightest reason for the young Eskimo to occupy himself in the same manner as his father.

56

The Formation

The Model

Natural Models
Without any hesitation, the Kuskokwim Eskimo reproduces every natural model if called upon to do so, no matter how unfamiliar it may be. There is no such thing, as with the Atutu-Baule, as one "not being able to represent something." Thus one can only write down here the varied frequency of the individual models.

If one takes into consideration that creating is done for the sake of content, not for aesthetic effect, it becomes obvious that, above all, models who act – animals and people – are portrayed rather often, and anything else only infrequently.

Animals
Seal, walrus, whale, fish, reindeer and various birds are the most important food-animals and are represented especially often: on grave figures in memory of the dead hunter, in masks to influence animal spirits or as animal helper spirits of the shaman; in painting and sketching, because one has more to do with them than with other animals, and thus more frequently has experienced something tale-worthy with them. Next in frequency come the fur-animals, mink, wolverine, otter, fox and finally the "dangerous animals", wolf and bear. Strangely enough, fish, so important as food, are not often carved on masks, and never painted.

Representations of People
They are found in performers' masks and helper-spirit visages, in grave-figures and dolls – see section "Functions" – and naturally in almost every painted drum picture, since some person or another is always the main figure. Sometimes he is absent, though, and only the end of the adventure is presented: the number of minks caught in a fish trap, the bird-egg found in winter.

68 Spirit of a codfish (Painter Timothy)

The fairy-tales, on the other hand, and their accompanying storyknife sketches deal frequently with animals only – for example, the adventures of the owls with her five 'owlets.'

Plants
Plants appear, as described under "Functions", in the plastic arts as masks representing grass or berries, as an attribute of the animal masks, to show what the represented animal eats. They appear very seldom in painting and drawing because they almost never appear in the story in any important capacity, and because scenery is given only in the barest form: a coastline, the surface of the ice. The sewing-purses of fish skin are trimmed with patches of colored duck-foot-skin, and these patches are often arranged as simple flowers. No one could tell me if this was done already before the arrival of the whites.

Sun, Moon, and Stars
The celestial bodies remained unknown to me in the plastic arts. In painting, a star was once done for me – in that long story of Lame Jacob of five men lost at sea in their kayaks (page 18, pl. 10), and when I proposed that John Boss draw me the moon, he immediately set to work and said that it is always drawn as a crescent. Then he promptly painted a sun next to it, but warned that he didn't know if he'd get it exactly round. Then he mixed a red colour. "And now, the way it looks in the winter," he said and painted a red circle around the black disk. Stars followed, first the "dog" of the moon, a small star that stands near the new moon, then constellations. As done by us, the stars are drawn with beams. "You know," he said, "sometimes the moon is completely black; then the shaman flies there and restores it." A girl who drew a star for me with the storyknife, printed two crossed pairs of lines in the sand. On the story-

knives themselves, "suns" are frequently incised, here as circles with rays, not to be confused with simple circles on the storyknives, which represent drums.

Rain, Rainbows, Clouds
Of the sky phenomena, only the rainbow is frequently represented. It is drawn on the kayak in front of the opening – a meaning could not be given – and Lame Jacob drew one as a family mark vertically around his bowl, with the nice explanation: the bowl is really a well. He painted a red and a black stripe next to each other to signify the multi-colors on the rainbow. He also painted it on the underside so that there was a band around the entire bowl, "because the rainbow *does* go down around the entire earth." He said something to his wife, which, according to the intonation, was probably: 'Such fundamental knowledge should certainly be surmised.' John Boss painted rain for me with many small lines. They went diagonally across the page and he explained that this was rain with the east wind. The rain did, indeed, go diagonally across the page down to the left, in the East-Western direction of the map. North is, apparently "up" to the Eskimo. I never encountered lightning or the northern lights in paintings.
None of the sky-phenomena are portrayed in the plastic arts, whereas the neighbouring Indians carve masks, which, for example, represent a mountain with clouds.

Landscape
The landscape is highly stylized. Usually the portrayal of the landscape for a scene forms the beginning of a painting, often of a drawing. It consists of a straight line or a double line for the tundra or the riverbank, a double wavy line for a river, or two arches for two mountains. Therein, then, the people concerned are painted.

Artifacts
They are represented fairly often, since they play a part in most of the stories. In the paintings we see the traps, the kayak, the sled. The drawings of the girls almost always begin with the igloo in which the protagonist of the story lives.

Models
The artist does not work directly from the model. He does not look at the dog which he is painting or the walrus whose mask he is carving. – "He has it in his mind," said Charles. In contrast to West Africa, there are also no models of mask types.
I sometimes asked the mask carvers in Alaska to carve using a particular model, because I wanted to see the results of an already existing work – for example, the mask for the shaman-trick (page 38). They looked at the object only once, and granted it no further notice, but deviated, because of that, from the model in the new mask. Not even an example for the family mark does one use. However, sometimes a sketch with brush or pencil was made for me before the execution of a painting, and Peter in Pupok even carved a little mask quickly to show me how the commissioned wolf-mask was supposed to look. In painting, it is really baffling how the once-sketched representation remains in the mind of the artist: the large picture is made exactly like the sketch, even if I meanwhile took it with me to my tent.

Imaginary Models
The Southwest Eskimos believe in the existence of really non-existent animals, not to the extent, however, that one always "sees" the invented animal, like a unicorn or dragon, but that this or that hunter encounters at some time a very remarkable animal, a mink with three stomachs, a wolf with a human body. Repeatedly I was told that there used to be such animals in the past. Along with the following drawing

(pl. 97) I was given the explanation that it is an eider duck holding a crab in one foot and a fish in the other when it was caught. I suggested that ducks could not hold anything in their feet. Answer: "In the old days they could." If one digs deeper, one finds that nowadays one still encounters mythological animals, and that only fear of ridicule first banished the remarkable animals to the realm of grandfathers. John Boss said, laughing heartily, that the only thing he has seen of this sort was a man with six toes. Still, I found a man who was well known because he was supposed to have had an experience of that nature. He was called Ivan Neck, inhabitant of Bethel, about forty years old, and in every respect a normal man. At first he didn't want to tell me the story because he still got frightened about it even though it happened a long time ago. For that reason he had told it only five times in his life. When I finally met him in his house, there was the special hindrance that so many women and children were sitting around, who would become terribly frightened. Finally, however, he related his adventure and quite willingly then; the rumour quickly spread in the neighbourhood and soon we had the entire house full of listeners.
He began: "It happened in the spring as I worked for the reindeer herds down on the Eek river. One morning I took my traps but did not want the other men to join. I started early from the camp. First I had to traverse brushwood, then a meadow, then the little trees on the bank of the Eek river. As I stepped over last year's grass I heard a rustling sound. But more than that: in my ears, too, I had that rustling. I carried my shotgun with me, no other weapon. When I first heard that noise I stood still and now I also heard a howling noise from somewhere below.
First, I thought it might be the headman of the reindeer herders who wanted to give a signal. (I myself owned four reindeer). I listened. But that noise must be something different. I followed the

sounds, rifle in hand. I had mukluks on my legs. Always when I approached it, it sounded further away again.

When I realized that something was uncanny with that noise I quickly went to inspect my traps and then hastened back to the camp. Just now the sun set. I saw birds fly off the bush, but not as usual with some noise but very quietly. As I now approached the camp and the flood of the river flowed out I heard some geese. I thought: 'well, I should at least shoot some geese.' But when I came to the spot where I had seen them – again there was nothing. I went up and down the river but I saw no birds. Then suddenly again the roaring noise!

I thought: 'that should be some strange animal! What could I do?' I squatted down at a cottonwood bush. Down there was the river.

Now the noise came closer. And all of a sudden I saw that thing. It was like a man but all black with arms down to the heels. It had a face. It was on the other side of the river. I thought: 'Will it come over?' But it did not come. But at this moment it came walking over the water almost without touching it with its feet. Every few yards it howled. When it had come rather close it once lifted its head to howl; thus I saw that its head was like the head of a bear with a mouth from ear to ear and teeth about an inch long. As it was just opposite me, it stood still and howled and now I could see that instead of ears it had small horn-like things. I stood quite still because I thought it could see me. It now stood at the river bank. As I thus watched it, I noticed that it stood about half an inch above the gravel – it did not touch the stones – and just like that it had walked on the tip of the waves before.

There I sat all crouched behind this bush. At my left I had a stick, at my right, my rifle. I thought: 'Oh, if it eats me – my parents who are respected mission helpers will think that I drowned and they had always said, a lad who perishes in the water must be rather dumb.'

When the animal came nearer and nearer I thought I must shoot! My thoughts went very quickly for I was in danger. However, I recalled that it is said if ever one encounters such a being one should not shoot for that would be like shooting at oneself.

When it was only a few feet away from me I thought: I will aim a few inches aside from it to frighten it away! I lifted my gun to bring my leg in a better position, stuck the stick under my arm to aim better and pulled the trigger. When it had come quite close I rose, roared and shot at the same time and then I fell unconscious.

When I recovered I found myself lying far off in the tundra, but in exactly the same position in which I had fallen down there at the river. But I did not have my bag on my back. To my right I saw a faint light. I lay with my eyes looking eastwards. Now I saw that in this direction tracks led away from me; but strange, they were as if cut out, sometimes one on top of the other. I felt an urge to follow them – they might lead to my camp. But then I remained undecided whether I should follow them because I did not know whether, maybe, I was in another, in an altogether different world. But I felt that I was breathing; thus I knew that I was alive. Yet I thought I had died and felt sorry. What should my father, my mother and my sisters and brothers do for whom I had always provided food? Thus I stood on this spot. I had not yet moved one foot as I had a strange idea. Just before I left the camp I had tried to wake the wife of one of the reindeer herders, but she did not wake up. This now came to my mind just before I tried to walk off. So now I took all my force and made one step forward but everything turned around me and my ears buzzed. I fell on my back, legs stretched out and now I fervently prayed to God. After I had prayed I tried to move my arms but I could not – neither the legs. The right hand which had held the rifle was stiff, only on the left hand could I

move the fingers a little. I continued to move the left hand until it went quite well, but the leg and the right hand remained stiff. The sun was again about to set. My entire right side was paralysed. I bit my hand to find out if I had feeling in it, but it was altogether numb. I supported my elbow with my stick. At last my arms and legs became movable. Now I remembered what had happened and I was much oppressed and frightened. And I was very thirsty. So I got up and went to a little creek. When I bent over it to drink I saw my own face and the entire experience came back to my mind.

I ran to my gun and shot like mad in all directions to appease my excitement. I was terribly afraid. I still had four cartridges in my hand and two in the gun. I thought: the first thing I see I shall shoot to death!

I continued on my way, my rifle ready to shoot, across rivers and lakes. I did not care whether I waded in water up to my shoulders – I only wanted to reach home before dark. As I approached my camp I wished nobody would be in my tent. I wanted to be alone.

My comrade was not in the tent but stood a little apart, and he told me later that only the upper part of my body was myself, below just a black lump. Nobody was in my tent. I was content. I did not want tea. I only thought of my dreadful experience.

I lay down and stretched out like a dead person. I said to myself: I am cold. A woman came and took my clothes off. I was entirely helpless.

I slept all night. The next day I was as healthy as ever. But two days later I had an awful dream of the same event. I saw the animal man come into my tent and he looked the same as the other day. There were other people in my tent and a woman saw how I just fainted in my dream. She pinched me three times.

After that I had stomach trouble for two or three years and even nowadays I have it from time to time because I have seen this strange thing.

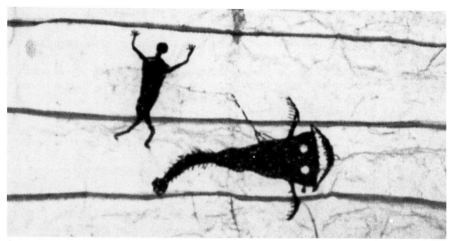

69 A swan changing into a fish (Painter Charles)

Yesterday, when you asked me to relate this story, I did not want to because I always get so frightened when I do it."

Upon my questions, I learned that his stomach troubles consist of painful flatulences. The friend who had seen him coming home after his adventure was now in Canyon Creek and his name was Gay Dagljuglrea. The narrator had seen "other little things" in his life, but this had been his great experience. He had seen, for example, appearances of dead persons. One put himself in his and his friend's Anguljaluk's way when they had gone to draw water. The dead person said: "Why do you draw water so early?" Then he asked them to take him on their back.

Sometimes these mysterious animals are figments of the imagination, as for example, the kayak-animal of Kusma – a lengthy animal with three transparent stomachs – but usually they are really existing animals with some strange qualities. Very frequently one encounters animals with huge holes in their stomachs (see pl. 14, explained on page 21). Many times animals change into something, as in the case of Charles' swan-fish (pl. 69):

"A hunter had hit a swan but when it fell to the ground it changed into a fish. He died when the hunter was at his side and only the wings were left of the swan!" Frequent are animals with human traits, not to be confounded with the Ichzit of the Nunivak Islanders who are goblins with half human, half animal faces. These beings are always animals with extraordinary qualities, not humans with animal features.

Abstracts

The only abstract notion I encountered in painting and drawing is the representation of direction. In Johh Boss' kayak story, plate 61 related on page 77, one can see how the kayak swam from the sea to the land. A line connects the two pictures of the kayak. Language or invisible qualities of the portrayed figures are not found.

Ornaments

According to the attitude toward art described under "Fundamental Principles", ornaments as products of purely aesthetic determination must seem unimportant to the Kuskokwim Eskimo; in fact, they are scarcely to be found at all, and where they are found, they are unusually sparse. On earrings and vessels one sees a pair of dot-and-line compositions, which can hardly be called decorations. As mentioned, pictures of the sun, of drums and of animal legs are used as ornament-motifs on the drawing-knives. Otherwise there are no ornament-figures of any significance.

Materials

Sculpture

Wood is the main material for the sculptures of the Kuskokwim Eskimo. Only very seldom does one encounter a doll's head or details like handles of small knives made of walrus ivory.

Wood, in the majority of Eskimo areas in Alaska, is driftwood, because the tundra in the coastal region has no trees. On the Kuskokwim it is precisely the treeless section which has the richest wood-carving. Most years there is an abundance of driftwood, such an abundance that at least one weekly sweatbath is possible. Usually there are trunks which have broken off further up-stream from the slopes of the shores worn away by water and ice: cottonwood, birch, alder and spruce. All types of driftwood are worked: alder and willow for bows and arrows, birch for bows, and spruce is probably the most important raw material on the Kuskokwim – kayak-frames, sleds, bowls, spoons, weapon shafts, thick planks for the storage house, and much more is manufactured from its long, straight trunks.

For the sculpted art-works the Eskimos use only easy-to-carve wood, spruce and cottonwood, because the carvings are not designed to last, in contrast to those of the Africans, which, for long endurance, are carved from hard wood almost everywhere. If utilitarian objects are to be made of spruce, one chooses the piece from the root, where, because of its greater resin-content, it is somewhat more durable. Also, undried wood is never used, because one knows that green wood cracks easily. But it is never artificially dried, but taken to be fashioned without any preparation.

The choice of wood for the mask follows studied deliberation, because the driftwood is often rotten in places and good in others. I saw Zigeb and Alexi hew off three pieces in succession, and after trial axe-strokes, I saw them throw them away until the suitable one was found.

Since the grave figures as well as most of the masks are supposed to be convex lengthwise, the wood is chosen so that one side can be formed from the surface of the trunk; the natural rounding will thus save carving. If the mask is supposed to protrude, however, as with a fox mask, the piece of wood is worked so that the face stands perpendicular to the grain of the wood; in brief, one aligns the block so that the grain goes in that direction in which most of the carving is to be done. In the first case, then, the grain runs in uneven waves across the carving; in the second case, in circles around the face. Aesthetic considerations of the grain are not taken.

Finishing touches are put on the wood of bowls, tobacco boxes and spoons only, which are rubbed with seal-oil to make them tougher and more durable. Once in use, the piece is never further worked on.

The masks and grave-figures have numerous additions, in part of wood, in part of other materials. A fox gets moustache hair if possible from a real fox, a wolf, teeth carved from ivory, the sea gull gets wing-symbols of single feathers stuck in the rims, the grave-figure ivory eyes, and so on. Walrus ivory finds its way through trade among the Eskimos from the coast to the villages on the Kuskokwim. On the coast the animals come in November and December with the ice-packs from the north and migrate northwards again in May with the last ice-floes past our area. They are killed from the kayak with harpoons (now often with guns); the tusks are knocked out with an axe and are stored without further treatment until they are used. They should, if possible, be without fissures. The best pieces are made from the tips, since about one third of the tooth from the point on is without core. The core of the tooth itself is also workable, however; in larger pieces, as perhaps harpoon-socket pieces, one usually sees core as well as good ivory. The core is considered ugly

and is therefore always avoided for the main surface of the carving, such as for pieces done for the white man.

If the tusk is to be sold, and for this purpose made more attractive, the outermost layer of the hollow, raw end is rejected, and the remaining cavity is scraped clean with a knife. The surface is polished with a crude cloth.

Nelson reports that immediately before use, the ivory is laid in urine to make it softer. On the Kuskokwim this is not customary with simple carvings, but does occur when a longer piece of ivory must be bent for a skid of a sled. When the carving is finished, it is polished with the grease of the carver's nose wings. In use, the ivory takes on a tea-colour patina after a few years.

Frequently old ivory gets washed out by the rivers and streams. It then has a brown or, if it has lain under saltwater, green color, the older, the darker and one can even find black tusks. The discoloration reaches deep into the core of the tooth. Yet the tusk does not darken evenly but in various shades with streaks. Due to this characteristic, old tusks in polished form are extraordinarily beautiful and used by the Eskimos who carve for the stores and for New York jewelers for bracelets and ring-stones. In the North the Eskimos discovered various tricks to make the ivory artificially old. I asked the carver Timothy on Nunivak if they have ever boiled ivory in tea; he denied it, but showed up the next day with a wonderfully browned piece and thanked me for the recipe. For themselves, the Eskimos use old ivory only if they can't get any fresh ivory, because the latter lasts longer. I encountered only two new pieces of old ivory: a handle carved as a walrus from the Girky collection (Bethel) and a harpoon socket-piece from the collection of the teacher Jones (Kipnuk), both evidently not aged after the carving.

The mammoth tusks which are sometimes found are never used for native purposes. For small picks, handles, etc,

walrus teeth, about four centimetres in length, are occasionally used.

Painting

The Kuskokwim Eskimos use for their sculpture and painting all kinds of paint: white, black, blue and red which they get from mineral deposits of Nelson Island through trade with the natives there, when the latter come to the Kuskokwim for salmon fishing. Black is coal of which there are various kinds which lend themselves in varying degrees to painting. White is chalk. Red and blue derive from decomposed rocks; they are taken up in lumps and easily disintegrate into flour-like powder. On Nunivak, at Nash Harbor, the one hundred metre high cliffs, which surround the bay for a considerable stretch, consist of such blood-red rock. The natives know specific places under the grass where the material has decayed sufficiently to serve for painting.

The layer of red on Nelson Island originated in the time that the old raven lived there. When her daughter was of marriageable age, she had to, as all Eskimo girls hereabouts, live alone in a hut for a year. (In this way the Eskimo girls allegedly gain all sorts of good qualities: since they only see things at close range in their hut they can still see at a distance in old age: they have thus conserved their eye-sight. The isolation probably serves the purpose of keeping the girl away from men as long as she isn't yet mature. On the Kuskokwim complete isolation is not required. The girl just may not leave her parents' home.) On Nelson Island the cliff house may still be seen where the raven's daughter lived during her year, and on that spot where her toilet was, the ground was colored red from her menstruation blood – "that produced this red colour for us today."

Zigeb described the production of colour through a trick of the shaman: he kneels on the ground of the men's house over a bowl, spreads his rain-gutskin over him, makes strange noises

61

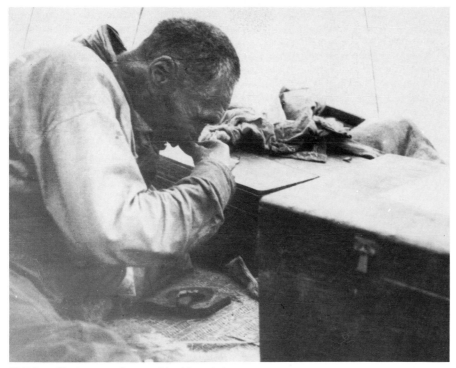

70 Painter Charles extracting nose blood for painting

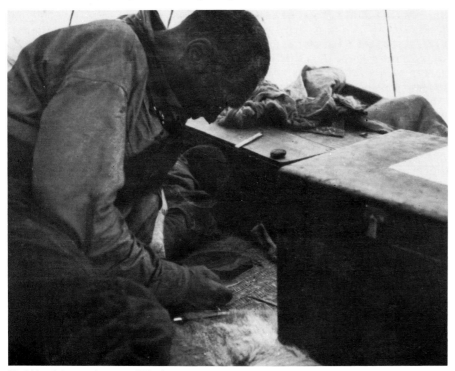

71 A blood drop at the nose of Charles

and suddenly he pulls the bowl out and it is full of colours.

These colors are easily mixed with water. They are ground with a small drop of water on a rough surface, usually a stone, and water is added, drop by drop, until the right consistency is achieved after about ten minutes. Thus it is proper for sculpture painting. The color is smeared on with a wad of grass which the painter must chew on in between, so that it becomes evenly soaked with colour. This tuft of grass is stored with the paints in a small leather bag.

For the paintings this simple method of paint-preparation does not suffice. The painting is done on walrus-stomachs, with which the drums are covered, or on seal-gut, of which the men's house window is sewn together, or on the leather cover of the kayak. These materials have the character of parchment or wax-paper. They are so smooth that the customary water-color simply scrapes off after drying. Therefore, black and red are mixed with blood, in fact, with the nose blood of the painter himself. I myself saw and photographed how Charles with a little stick about the size of a toothpick, bored in his nose for two, three minutes until it bled profusely (pls. 70, 71). He let the blood drop on his paint palette of stone at least five minutes while he twisted his nose around with his thumb when the blood was not coming out freely enough.

Then he sent his little son out with a tin to fill it up with urine and bring it back in. He dipped his brush of squirrel hair into the urine, dropped some of it into the blood and stirred for a long while (see also page 68). Then he began to paint and in between, kept dipping the brush into the urine. For a large picture such as his Reindeer story (pl. 14) he had to repeat the torment with his nose half a dozen times, because he could not tap much blood at one time. But thus the paint adheres well to the smooth material. Since then Charles's pictures withstood much suitcase packing, the same

62

as Kusma's, who also painted with blood. The same proceedings are employed in wooden-bowl painting; here the painting surface is better suited, but afterwards the painting is exerted by filling in the bowl with food. The bowl paintings are therefore additionally "burned in." When on the first night of the Bladder Festival all the bowls have gotten their marks (this work takes up the entire first night) then, in the morning, they are placed on the shelves along the walls, and then a terrifically hot sweat-bath is held which only the most hardy sweaters dare to join in. Thereafter the colours have been well absorbed by the wood and have become hard on the surface.

Colours are never mixed. One sees two different colours in one picture only in individual figures if a particular quality is supposed to be pointed out, for example, in the case of a rainbow with a red stripe next to a black one. Never are several colours used to indicate the multi-coloured nature of a scene. The paintings are thus always of one colour: on drums and windows black or red, on bowls black, on kayaks black or blue.

On the whole, one could say that the Eskimo artists have it easy to find suitable material for their works and that they put these materials to use without any great display of understanding, with the exception of the mentioned blood-urine mixture, which solves a difficult technical problem.

To be sure, painting as such is already an ethnological rarity, and still more, the art of drawing, which elsewhere originated only after the discovery of complicated technical media, here exists in absence of suitable media. The small girls should really be marvelled over, the way they produce a drawing surface on the smallest space in uncomfortable surroundings, in summer and winter; lying on their stomachs, they oblige the awkward instrument to difficult drawings for hours on end.

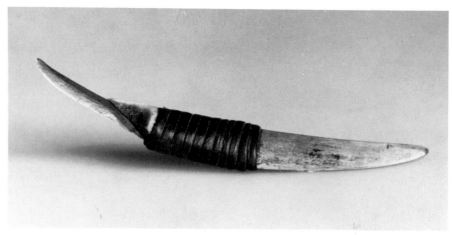

72 Old carving knife with bone handle and steel blade

Technique

Sculpture

The old implements here in the Southwest are almost extinct, but the technique is unchanged because the iron tools are made by the Eskimos themselves exactly like the old stone tools. Strangely in the north of Alaska, where the Eskimos are otherwise much more under white influence, stone, bone and ivory tools are still commonly used: broad stone knives to cut fish open, picks of walrus bone to dig up sod for house-building, rakes of reindeer antlers, and so on.

Only two carving tools are known: a small adze with a lateral blade and a crooked knife.

Nowadays a pocketknife is also used sometimes but only for certain cuts, not as a substitute for the crooked knife. For the adze "green stone" was used, which was tied with a sinew to the oblique end of the handle, and for harder material, a little jadite blade, which was set into an ivory socket; this was tied to the adze.

Wood and ivory was worked well with this, even without the softening of the ivory in urine mentioned by Nelson. In the north the jadite comes from a mountain on the Kobuk River, the Jade Mountain. I didn't find out where the Southwest Eskimos got their jade, but since the Northern Eskimo annually came to St. Michael to trade, they could well have gotten the material from the Kobuk. Nowadays an iron blade is fastened in exactly the same way. For the haft wood was used then as today, formerly also reindeer antler. The length of the haft amounts to about 30 centimetres, that of the blade plus blade-holder about 20 centimetres.

The crooked knife used to be made of a light, bent, shallow piece of antler, in which a sharp jade-blade of about two centimetres was set into one side of the edge near the end. Today, instead of the stone, a five centimetre long iron blade is used, which is made of trap-springs. It is fastened with a strip of leather in front on the handle (pl. 72), whereas the jadite-blade used to be stuck in the side of it. This crooked knife deserves special attention because it is the handiest and most workable carving tool that has ever been invented. The surface of the blade is slightly curved inward, more so towards the point than towards the handle, so that the edge, depending on how it is applied, carves off a smaller or a larger piece of wood, thus performing finer or grosser work. If the blade is applied close to the handle, it cuts like a straight knife, further forward, concavely. The

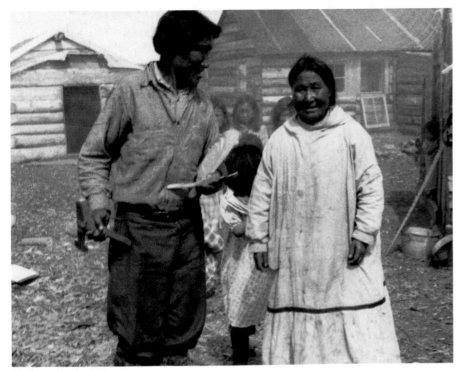

73 Carver Vasil and his wife

flat antler haft is itself a dull knife: with it, even-grained woods are split, for example, for black-fish traps, for which four-metre long, thin sticks of wood are used. The concave knife is wonderfully handy: for fine carving, the hand lies forward, the thumb nestles comfortably in the curvature of the blade; for long-cutting the handle is held further back in the flat, closed hand, so that the flat handle lies between palm and fingers. With this knife the carver carves toward himself only, never away from himself.

On Nunivak, every man has a whole set of these knives. As a non-expert I couldn't recognize in what way they used these for different purposes, but I often saw the carvers in the men's house thoughtfully choose a particular one, put it aside, and then borrow one from a neighbour. They are well aware of the astounding virtuosity with which they are able to carve with these tools. They often "demonstrated" for me, that is, showed me the various manners of carving; first cutting off heavy pieces, then more cautiously hollowing out a spoon, and everytime at the end there was a very delicate stroke over the wood, in which the knife took only very fine shavings, so that the carving hardly showed traces of the knife.

Very often the carver sets out to sharpen the knife intricately and with great deliberation. He has various sharpening stones which are found up-river, and uses, besides, his shoe-soles, thumb-balls, and shirt-sleeves, in order to make the blade so sharp that, as the Nunivakers maintained, I could shave with it. I tried it out in public after an abundant lather, but the experiment ended up with general disappointment, since I had the same stubble that I had had before. The following day, however, they had figured out that it happened because the man in question sharpened the knife with a worthless American whetstone. Indeed they shave themselves with the crooked knife, directly after the sweat-bath

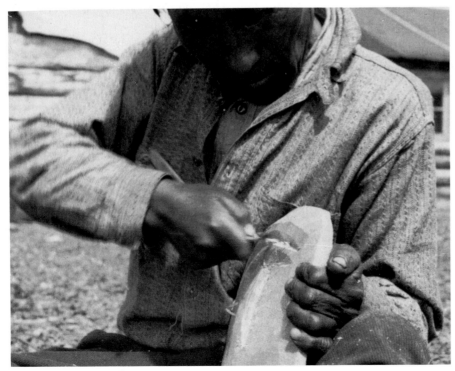

74 Vasil carving with a knife

when the hair is softened by the sweat, thus without soap. I myself participated in a sweat bath on Nunivak and observed this.

To saw wood and – so they say – to saw ivory, saws were made earlier of reindeer shoulder blades until the whites brought steel saws, or the ivory was rifted with a sharp stone until it broke, or a number of holes were bored near one another and then the piece was broken off.

We will now witness the construction of a mask, as the most important object of plastic art, as it usually progresses:

The work place is always the men's house. There the carver squats on the ground, in one of these positions, according to the particular need (the disk signifies the mask, which is laid on the left leg; the legs always lie completely on the ground, only in position 4 on the right is the left leg raised).

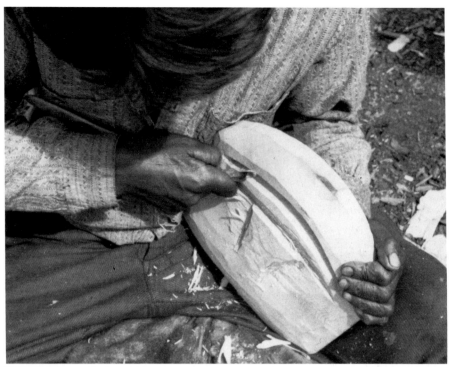
75 Carving the mouth of a mask

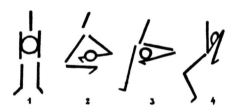
77 Body positioning while carving

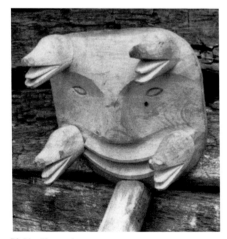
78 Vasil's mask

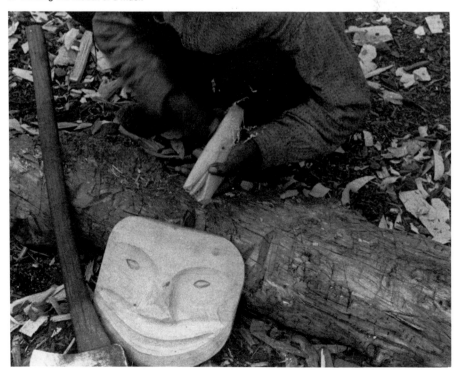
76 Carving small heads to be attached to the mask

65

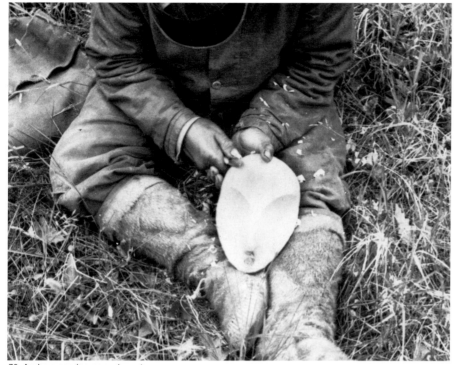

79 Andrew carving an owl mask

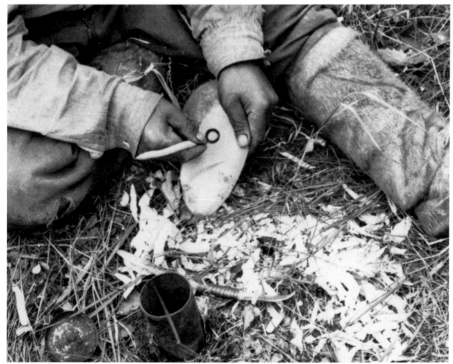

80 Carving the eyes of the mask

With a longhandled American axe the block is chopped at least to the point that the circumference of the mask is determined and one side is straight while the other is convex. Usually the work advances further with this crude chopping: if a human face is being formed, then the deeper lying parts of the cheeks to the left and right of the nose are chopped out or with a seagull, for instance, a cone for the beak. It is noticeable here, as with the use of the following instrument, that the Eskimo carver works essentially further with a heavy tool than a European would do, and not diminishing the quality of the work. There is no false stroke. The firm conviction, free from any wavering, gives one pleasure to see at every observation.

It is almost agitating, however, when the artist takes the aforementioned pick, then, to do detailed work. Without pausing for an instant to consider the matter, and without drawing anything or at least marking it ahead of time, he hacks into the wood, as if he were chopping a tent-pole. Twice during this phase I wrote down that the observed artist could never before have made a mask and was just trying to earn something from me – and still a beautiful mask was ultimately produced.

For an hour the work remains in an unattractive, unrefined state. One barely notices any progress and can, as observer, conclude nothing about the final appearance. In reality, however, the true structural work is being done: the surfaces get their proper state and form. Whatever comes later, is simple compared to that, even if it is more striking for the onlooker: the completion of the surfaces which suddenly lets their significance be recognized, and the addition of the liveliest facial features, eyes and mouth.

The latter is the duty of the crooked knife. First it helps to form the surfaces properly, there where the pick can't be used, for example, directly under the eyes. It is a pleasure to see how the ef-

fective and confidently directed tool with a long cut takes away exactly that portion of wood which is superfluous. A half dozen cuts bring forward a new facial feature. One almost has the impression of work done with clay.

Then the knife, held by the handle so far, is grabbed toward the front by the leather binding, thumb on the blade, and with short slices the details are formed. Finally the mask is evened with the described "easy" carving; the raw adze-traces are smoothed and "line" is put into the facial features, into the bird's beak, the fox' snout.

Only now does the artist pause from time to time to hold the mask in front of him with outstretched arm, head tilted, to look at it. Then follows the improvement of two or three areas, a cheek too high or the forehead, to which they give remarkable importance.

After such a pause, the artist takes out a pocketknife or a hunting knife and carves the eyes and the mouth. Without testing, without first sketching in and balancing out, he imprints the outlines and then bores and cuts from behind if the features, as often with animal masks, are to be cut not only on the surface. Andrew gave his owl its round eyes by imprinting a circle in the wood with his thumb nail and then carved these out with the knife. William took a full hour to carve out the eye-sockets of a human face properly. At intervals the crooked knife keeps finding work, for example, to give the bored-out mouth a graceful, half-moon shape.

This description is schematized for the sake of clarity. Actually, the work is quite a bit less systematic, and even so much less that this strikes the observer as astonishing. The artist might, while drilling out the mouth, put away the pocket knife in order to smooth the forehead with the crooked knife for a longer period of time, then return suddenly to the mouth. Sometimes in the middle of working, he turns the mask around to the back side and hollows it

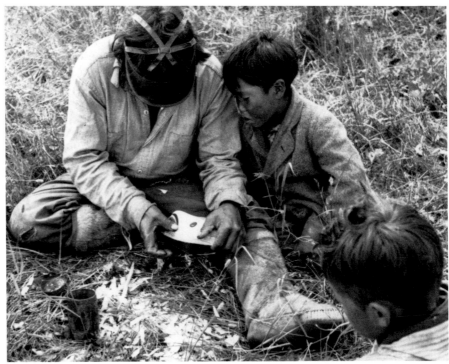

81 Painting the mouth of the mask

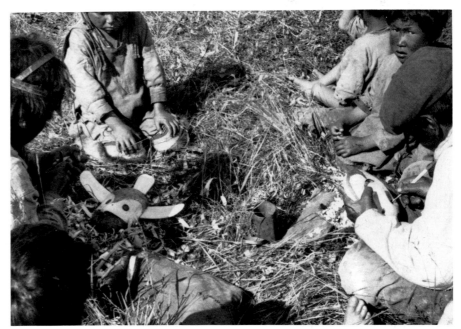

82 A group of carvers working together

out for a while, then returns to the work of before without having completed the hollowing out. It doesn't give the impression that he does this to rest; rather, this flighty manner of working is their habitual mode of work.

Thereafter follows the construction of the ornamentation of wood, feathers, hair, ivory. To set them in, holes are bored into the rim of the mask with the knife-point.

The painting is usually done before the ornamentations are set in, because the latter are usually to be painted as well and this is easier to do while they can be held in the hand individually. As described under "Material", the paint is prepared with water; a wad of grass is dunked in and this is then chewed with the paint until it is evenly distributed; then it is rubbed onto the wood. Dunking and chewing and application are repeated until the paint covers the light wood, which doesn't always succeed.

With that the artistic work is done. On the back of a mask a small stick is set in horizontally across the hollowed-out part; on this the dancer holds the mask with his teeth during the dance.

A mask can usually be finished in one day's work of 6 to 8 hours. This was the case when work was done for me. On Nunivak they took several evenings. Lame Jacob confirmed, as he carved the dance-staff, that the small things, which are smaller than the palm of the hand, often require more time than the large ones. Customarily they are very inconsistent in working. That's the reason why the whites use as little native manpower as possible. An interview could seldom last longer, for example, than one hour, whereafter the answers got sluggish, and all at once the artist stood up and announced: "It just occurred to me that I could now take a sweat-bath."

Painting Technique

The painting surface is the cut-open stomach of a walrus, which has previously been stretched out while wet over the frame of the drum and has been fastened with sinews. The size of the drums varies between 30 centimetres and one metre in diameter. The surface is rough, like parchment paper. Or the gut of a seal is taken, if it concerns a window of the men's house, about a square metre large, sewn together of strips about 10 centimetres wide. This material is especially smooth, resembles wax-paper closely, and does not take paint readily. Besides, the painting of the window is made more difficult in that it is not stretched out as is the drum.

The painting instrument is a brush which the painter makes out of squirrel hair which he sometimes just cuts off his parka and then, as with us, simply sticks into a piece of wood of about 15 centimetres. He uses less hair than we do for a water-color brush of medium strength and leaves this about three times as long. He licks the hair and then cuts the point off straight at the end: the brush then doesn't come to a point at the end as ours do.

The work-area is the floor of the men's house. Most of the painters sit and take the drum or bowl on their laps. Now and then one will lie down with the drum in front of him on the ground.

If the painter is lying down, the entire underarm rests on the painting surface; if he is sitting, the hand is usually on it. He holds the brush as we do a pencil, and fairly far to the front. The painted line is made by extending the brush with the fingers and then by bending the fingers; the brush is pulled directly towards the palm of the hand. Thus the lines are drawn very slowly. If I give the artists a pencil, they draw with it with the same highly awkward, forced movement. Larger lines, for example the traps in John Boss' picture (plate 60), are not drawn with a hand resting on the surface; rather, it remains immobile, and the line is drawn from the shoulder joint; only at the end are the fingers somewhat bent (pl. 61). It isn't clear to me why the paintbrush-tuft is so long, for this seems to make the painting much more difficult. Such a large portion of the hair is posed on the painting ground, completely unmanageable, that it is very difficult to paint small things with it, such as the teeth of a wolf. Still, only once did anyone make an error (Kusma) which he had to erase, and the pictures, especially Timothy's, show that, in part, very fine representations are produced (pls. 3–9, 23, 99–102, etc.). Never "does he go outside the lines": the ribs of the bird are drawn exactly to the outline of the body, the flippers of the seal are exactly symmetrical. After almost every brush stroke, the brush must be licked and after about every third stroke must be dunked in.

The painting of bowls takes place in a festive context. In the first night of the Bladder Festival all the men and boys gather in the men's house. On a ridge which runs all around the men's house, above the sleeping place of each man stand the bowls and spoons which have been made the previous long evenings. It must be known that like all economic activities so also the trades are each practised at a certain season only: Kayaks are built in February, boots are cut and sewn in December. Dishes are carved for the Bladder Feast and at no other season. The new dishes have been brought to the men's house nicely coloured in red, between fifty and a hundred in number. Each man is proud of his work, for carving of dishes is difficult. Around the bottom a broad rim of spruce is bent, made out of one or two pieces, and the ends glued or fixed together with obliquely inserted wooden pegs (pls. 92–95). As the dishes are usually rectangular it is quite difficult to fit the rim to the bottom, especially if made from one piece of wood (pl. 87). It is achieved by carving the piece for the rim in differing thickness, thinner where it is intended to be bent around the

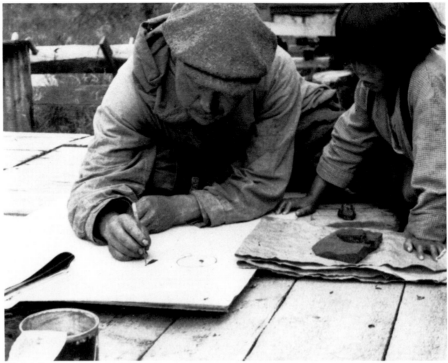

83 Freehand painting

84 Painting on paper

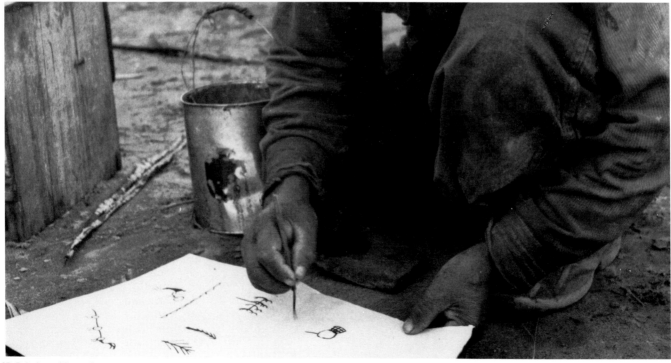

85 Painting with a twig

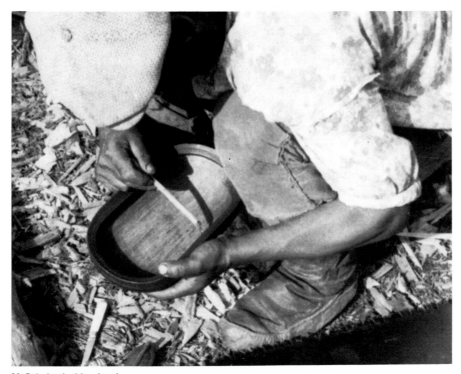

86 Painting inside a bowl

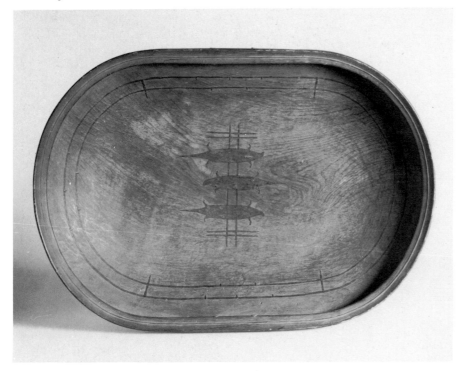

87 Bowl with painted seals (Ethnographic Museum Basle)

corners of the dish (pl.87). After which, as I observed on Nunivak Island, rim and bottom are hollowed out very carefully in a certain way to give the dish agreeable outlines and surfaces (pl. 94). On the first night of the Bladder Feast on Nunivak Island they then brought large basins made of stone – I first took them for potsherds of sealoil lamps, but learned that they are stones thus formed by nature. Only on this particular night are they used. In these, three or four men then rasped pit coal and mixed it with sealblood (not noseblood as on the Kuskokwim) and urine to obtain black colour. This mixing activity lasted for quite a long time, since a very particular composition must be achieved for painting in the dishes, so that the colour neither disperses nor becomes too thick to penetrate the wood. Again and again it is tested on a little piece of wood, then more blood or urine or coal is added.

In the meantime two other men had manufactured two dozen brushes. Now the painters formed three groups around three sealoil lamps and started to paint. They made themselves a kind of compass with two little sticks tied together crosswise. With this, they measured the distances from the frame so the picture would be at the right place and exactly symmetrical. Then they painted hour after hour all night, first their own dishes, then those of the non-painters. In between one fetched the large festival drum, sat on the ledge and they all sang.

When at last daylight came, the dishes again stood on the shelves in proper order, all with their family marks. Now wood was piled up in the fire hole, and most of us retired, for now the hottest sweatbath of the year was to follow, which only the hardiest sweaters were able to endure, for by this heat the colours should be burnt into the wood. Thus it happened, and on the following evening the dishes were "consecrated". Each housewife filled the dishes which her husband had manufactured

70

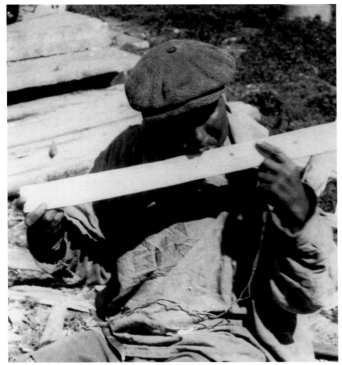

88 Biting the rim board to be bent

89 Bending the rim board

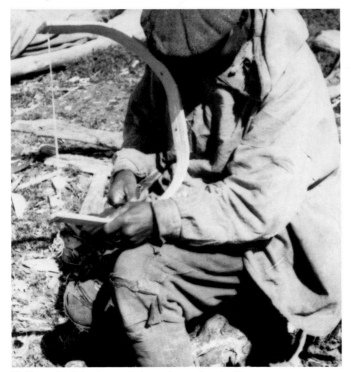

90 The ends of the rim are tied together and made thin

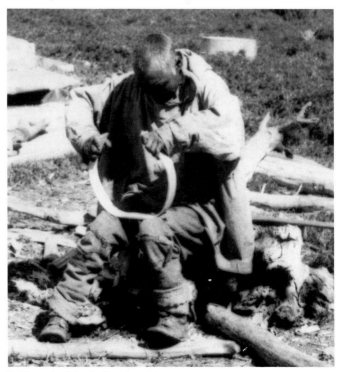

91 The ends of the rim board are joined

92–95 Dish with neatly fitted rim on a carved bottom

for her for the coming year with the very finest food which she had specially put away over the year – the best berries, the thinnest cut slices of dried salmon – brought them all to the men's house, and the men ate together.

The technique of drawing was described on page 28 in the introduction to the art of drawing. On account of the drawing ground (mud or snow) it is very simple and therefore not very revealing regarding the personality of the artist. If one looks over the technique of carving and painting it emerges that the former gives the artist a chance to achieve a high grade of sculptural quality. It en-

ables him to do whatever he desires to carve. In painting this is different. Here the artist is restrained by underdeveloped technique; technique shares with him the responsibility for the pictures to be as they are.

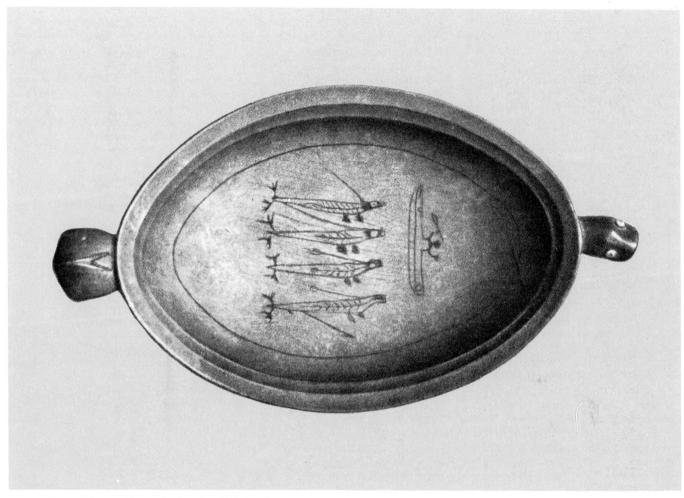

96 Carved bowl with painted hunter in a kayak and killed seals

Manners of Painting

Three styles of painting are applied:

1. The stroke manner, in which the body is painted as a characteristic line, then the extremities attached to it. This style is technically the simplest, but it requires the highest measure of artistic observation (pl. 16).

2. The most primitive style is the one in which the entire being is represented in a black plain by adding dot to dot, as was done in pl. 17, for instance, showing two kinds of seals, a mink and an animal called "Dachtuli" (painter Timothy).

3. Lastly there is the outline style, which represents its model only by a black contour and leaves the space inside void, or fills it with parts which are invisible in real life (pls. 102, 4, 21, 103, etc.).

None of these styles has individual tasks. They are all practised by all artists, and frequently the different figures of a painting are painted in the different styles, the painter not being able to point out a reason for their varying application. "It thus comes to me". In plate 61 a kayak is painted once in the outline style, twice in the "black plain" manner.

Construction

Figures

There is no general rule as to how a figure, human or animal, should be built up. Again one finds different methods which are applied by the same artists for the same objects, without visible or explicable reason. One can only state that as a rule the artist endeavours first to draw something essential and then, so to speak, attaches to this what remains. For this reason the trunk is usually painted first, then come the legs, then the arms, and, strangely, the head last. Lame Jacob with a man with a wolf's head even painted ribs and stomach before painting the head. Paul, with a man shooting his arrow, first painted the trunk, then the arms with bow and arrow, then the legs and finally the head. But this is not the rule. John Boss began his man on an icefloe with the head, and Kusma, for example, each time painted the head on the trunk before adding the extremities. John Boss for "the man in the kayak" in the adventure on the icefloe first drew a line for the outline of the body from vertex over occiput and neck to the back. Then he drew the outline of the front part. However, as stated, each artist may apply the other methods of construction in other cases. That relatively little importance is attached to the head may have two reasons. First, that it is easier to paint than the extremities, and secondly, since it usually has no facial traits, it is not as with us the most expressive, but the least expressive part of the body. The limbs can at least show movement, not so the head.

To build up a scene they observe this rule: first they must paint a basis for the composition. Usually this is done by one or two lines which run horizontally across the picture and represent the landscape in which the event is going to take place. Single lines mean land, double ones a watercourse, a double serpentine a river. Even better as a base is a trap in the middle of the picture, or a fishnet with many meshes. When I asked Kusma to paint clouds for me he said: "Then I must first paint the horizon so that I can paint the clouds on it". To paint clouds on the drumskin such as they sail freely in the sky appeared to him somehow risky. Otherwise I observed nothing extraordinary. Anyhow, I will cite what I noted how a certain scene came into being. John Boss painted the drum picture (pl. 60): He sits down on the floor and places the somewhat awkward object (the drum) across his knees. Then comes a rather touching moment. He dips the brush, then hesitates, looks up, smiles at me and says (he is the only one among my artists who speaks a little English): "I am little old; my hand shakes little bit". I told him that this was of no importance to me since my concern was mainly with the content and the method of painting, not so much its quality.

He draws a long line from the upper left side to the lower right, a second one above it and thus creates a rectangle which he now fills in with diagonal, crosswise-running strokes: a fishnet, he explains. "It is a small fishnet in a slough". A fly crawls across the stone on which the color was mixed. He dots it to death with his brush.

Left and right he paints a vertical line – sticks which are stuck into the mud – and now he draws the ropes by which the net is fastened to the sticks. All this he paints in the same thickness, no matter whether a thread of the net is meant or a stake.

"If the flood comes, fishes" he explains. Below, under the net, mud should be imagined. It was in a slough in the tundra. Only there such nets were used, not in rivers. This he repeats to make sure I grasped it, for now comes the story.

He paints an animal body in the middle of the net: first the outline, then he fills it out. "In such a net one of my forefathers, long long ago, had caught a muskrat. At the same time he caught two whitefish in the net!" He paints one fish to the right of the muskrat, again first the silhouette. He starts at the mouth and in one stroke first draws the left then the right outline from head to tail; then he fills the space between them and adds the flukes. Now he reclines and observes, wants to continue, but reclines again and turns the drum around. Evidently he wants to paint the second fish in exact symmetry to the first one, left of the muskrat, but when he finishes it, it does not quite fit. To paint such a fish he needs about one minute.

In the meantime the fly woke up again and requires further treatment.

Now, catching this muskrat was not even enough. Beside the rat and the two fish there were also two snipes in the net –. "I shall now paint the man who found the net with this prey; he was in a kayak". He draws a longer line on the left side under the net: it is the slightly curved upper side of the kayak. When the kayak is finished, a few details are added: the ropes, under which paddle and weapons are locked. Then he repeatedly repaints the bow of the kayak with its circular opening, until it looks smooth and proper. Only now the grandfather is placed inside. Again he starts with the head and draws first the line for the back, then for the front.

Tradition

The momentum of tradition is there consciously and unconsciously. Consciously in the contents, especially of the paintings, whose stories date at least as far back as the paternal generation. If possible one wants to paint really old adventures. Each time when a painter painted a story of his own family, he drew my attention to its old age, without my asking for it. John Boss declared before starting his story with the fishnet (pl. 60), that he would paint something of "father before father before father". When the fishnet was finished and before he started to paint the forefather with the magic kayak (p. 77), he pointed again to the age of his story: "My picture relates of the olden times, father before father before father." When he painted his family mark for me, he added: "These are the old marks". Lame Jacob, before starting to paint, said: "I want to paint things for you which I can (which I have always painted), nothing else". Betka: "This I have had transferred from my forefathers". Together with the paintings one keeps in mind the picture of the old times before the white people came. On a dance-staff of Lame Jacob (pl. 52) he carved the story of a man, who, as related on page 44, hung onto two swans and thus was carried up into the air. "Oh yes, in those days the Eskimos were lighter and more supple, not so clumsy as they are nowadays. They caught the animals by running after them". I asked whether the Eskimos in those days had lived in another country. "No, that was in those belligerent times. One Eskimo village attacked another one by surprise, killed as many as possible, only to suffer a counter-attack the following year. Sometimes several villages united under the guidance of a great shaman. Thus the Nunivakers had the Eskimos from Nelson Island and from Hooper Bay as allies and together with them faught the Yukoners (Eskimos, not Indians). Children were al-

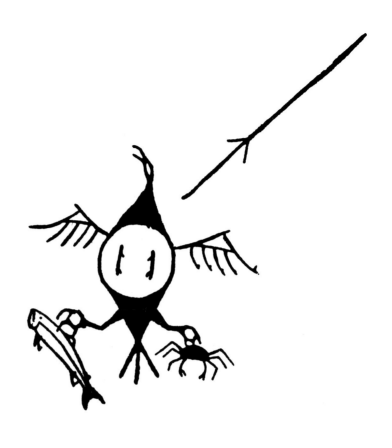

97 A slain eider-duck, holding a trout in one and a crab in the other foot

ready educated as warriors. They were not allowed to drink much water so that they would become slim and light, for they knew that running away swiftly is an important quality for a warrior too. The water bag or water pot was kept somewhere out of reach. When a boy came and said: 'Father I am thirsty', the old man would say: 'Spit on your hand!' If the saliva was still liquid, he would not get water. Only if it was nothing but a little foam he might get a good gulp. That's what made the men so light. That is how such a story as the one with that swan flier could happen." When he, Lame Jacob, was a boy, people were just giving up this education. Mrs. Jacob was brought up in that way. "And something else about being slim", he added. "When some boys were ready to get married, they were tested. A sinew string was tied to the waist of each of the young men so long that for quite a distance it slid on the ground and a feather was tied to its end. Then they had to race. Those who could run so fast that the feather rose from the ground and flew behind the young man in the air – well, such a man had developed fine. But once he was married and had a child, then he could drink as much as he liked."

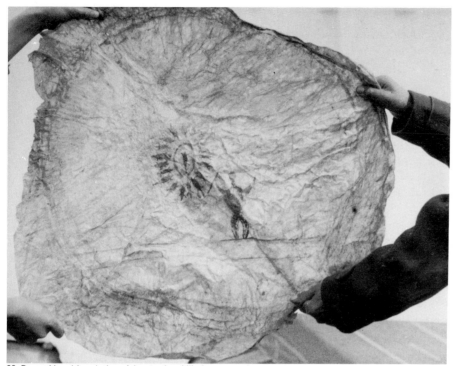

98 Drumskin with painting: A hunter has killed many seals

With the other dance-staff which shows the walrus with the foderbag (pl. 52), Lame Jacob said: "This was long before we had rifles, only harpoons, bows and arrows." In the drawings of the children the living quarters of the protagonists are still the old half-underground houses, although on the Kuskokwim none such existed anymore, far and wide, and strangely enough the fireplace is always omitted. "Because in the old days one had no fire – everything was eaten raw or frozen." I do not know what to think of this latter statement. It is a fact that the Nunivakers look forward to cold weather, for then they can have frozen food. Further north, at Cape Prince of Wales, children were raised with cold and lukewarm food because it was said that then they would not perspire if they followed a herd of Cariboo for two or three days to drive it towards the village. It also has to be taken into account that in these old dwellings fire had no heating function, because, as soon as it was lit, the entrance and the skylight had to be opened to obtain draught and to let the smoke out. Thus it is usually colder in the house when a fire is lighted than before it. On King Island in the Bering Sea I saw the women still cooking on a seal-oil flame. Perhaps here further south on the Kuskokwim, this was also the old way of cooking and it did not require a special fireplace.

In the course of time the stories undergo little changes, but not in essentials. Of the following story (see pl. 98) I have, for instance, two versions:

Andrevska: "It was once in the autumn in blackfish season that my forefather went to the river with a weir-basket. The river was rather far from the village. He caught so many blackfish that he could not carry them all home. So he dug a hole and put a large part of the fish in it until it was filled up. Then he covered it, went and thought he would come for them if they ran out of food at home.

Thus it happened late in winter. So one day he went for his sled, tied the dogs to it and drove to this cache. As he approached, he heard loud squeaking from the hole. He stopped his dogs, crept closer near with a club, and saw that the hole was full of mink who ate his blackfish and fought over them. Quickly he covered the air-opening on top and dug a little hole at the side. The mink got frightened and wanted to run out through the hole, but as they jumped out he hit them over the head with his club, one after another. When they all lay dead before him he counted them and they were exactly twenty, just as many as one needs for a parka."

Lame Jacob had heard that story differently. According to old Eskimo custom one should not kill more than fifteen minks in one season. He who acts against this rule will die. But since this man got his prey unintentionally, rather in order to kill the rapacious minks he could keep all twenty without anything happening to him afterwards.

Most stories, however, have such an outspoken point that one cannot alter them. They may be embellished with additional details, which has certainly happened with many of the stories told in this book, for example the story of the five men lost at sea (p. 18), or with the various stories about magic animals (the widow and wolves, etc.).

There is the unconscious tradition! Much in Eskimo life is done in a certain manner only because it was always done that way, and without knowing why it has always been done that way. When a woman dances she wears her child-parka to look like a girl. Why? Well, because it was always done that way. It is similar with art. Paintings look as they do. If someone would suddenly do it differently, for instance the way white people paint, well, then it would not be a proper drum-painting. A drum-painting looks a certain way. If somebody would want to propose some development, such as the introduction of perspective or several colours, the

others would say: "We don't see what you want. Either you paint the way a drum painting is done or it isn't one". Thus at least was my impression.

The same holds true for sculpture and drawing. A gravepost figure always has inlaid eyes of ivory, and a grandmother and grandchild story is always done with a storyknife with the grandmother on one side of the room, the grandchild on the other, never side by side, and the grandmother never gets legs, because the old ladies always pull their legs under their parka when sitting down.

Tradition in this sense is also prevalent in problems of which one would assume that their solution was left to the artist's individuality: the difference between male and female faces in masks and grave figures is indicated by upturned or downturned corners of the mouth (signifying "smiling" or "crusty"). The expression "furious" is shown by sideways downturned eyebrows.

In no case is tradition experienced by the artist as coercion, as a condition, as something one has to stick to. He does not consider that he might proceed differently.

The Customers

I have already pointed out that the Eskimo artist does not often work on command, but usually from his own initiative. But if a certain order is given, then the artist is bound much more to his commissioner than I found in Africa where "everything else" is often left to the artist. With the Eskimos it is often the shaman who orders a mask. He thinks up or dreams up what the mask should look like and supervises the proper execution of his ideas, and may even draw with coal onto the block of wood how the mask should be.

Kusma related that also those who asked a painter to paint their family stories onto a drum often tell him exactly what they want. Lame Jacob said, some would even sketch the picture into the mud, and he would then only paint it much nicer on the drum. They would tell him exactly: "Here a seal with his ribs inside his body, there the kayak with the rope –" then he observed: "First I painted the pictures with my hand and you wrote it down, and now I make them with my mouth and you write it down". And our entire audience laughed heartily. Kusma said that the man who orders a painting might say: "But you should paint it more black" or "this animal smaller, please." But only the man who ordered the painting may utter such desires – no one else can intervene.

Peculiarities

The point of observation

An object can be represented either the way the later observer would see it if he were a witness to the action, or the way the protagonist of the story sees it.

Example 1: On the picture in which John Boss paints his adventure with the swan and the porcupine (pl. 16) he first introduces himself sitting in his kayak in profile. But to paint the following scene when he landed on the island and climbed up the bank, he painted the kayak a second time, but, since the story has developed, the way he himself saw it from the island, namely, as seen from above.

Example 2: In the drawing of the girl on a river between two mountains (pl. 29), the river is drawn as seen from above, the way the spectator or the girl sees it; the mountains on either side, however, are drawn in profile such as the girl saw them when she passed by. Thus the view from above and the view from the side are united in one scenery.

Up to a certain degree the artists are aware of this problem. When they painted single objects they would tell me in advance in which way they were meant to be seen. "You look into the spoon, you get it?" said John Boss, when he drew spoons of different shapes for me.

Space and time

In order to show the passing of time in a picture, one must show the same person or the same object on one and the same picture in different actions.

The tales underlying the drum paintings are often long and contain several main events so that it is difficult to reproduce their course in just one scene. One especially desires to introduce the protagonist at the beginning of the story, and then naturally again when the main event occurs. Therefore, this person may be painted a second time in a second function. One does not paint a figure more than twice, but the same representation in one picture may serve in two phases of the story.

Examples: Miraculous experience of an ancestor of John Boss with an kayak that followed his call (pl. 60): Once upon a time there was a man who in his kayak paddled out into the Bering Sea to hunt walrusses. He pulled up at a large icefloe, drew his kayak half-way up and lay down in ambush. Once he looked around – alas, his kayak had disappeared! It had slid down from the ice and drifted way out into the sea. So he would miserably perish on the ice! "Dai – dai –" (come back) he cried in despair. And truly, the kayak turned and floated back to him like an obedient dog.

Here the man on the icefloe is first painted quite large, then the kayak on the floe. "This kayak drifted out to the sea", said John Boss. "I now paint it once again here on the open sea, but only small since I have already painted it big".

When he had painted it, he drew a line from the kayak in the open water to the one at the floe, to indicate that it returned to where it had originally been. Then: "And now comes my grandfather as he pulls it ashore with a staff". He paints a little man to the side of the first picture of the grandfather and draws a

line from his arm to the open bow of the kayak. Then the bigger grandfather receives a staff in his raised arms, so that he now represents the phase immediately before regaining the kayak: the man who ran back to the shore.

Now, we turn from the peculiarities which are related to the contents of the story to purely formal peculiarities.

Main views
An object is always shown in one of the capital views: from the front, in profile, or as seen from above. If the object is meant to be at an angle towards the on-looker in the picture, it is placed obliquely, but always in complete profile or as seen from above. If one need not take into consideration the point of view of the onlooker of the picture or of the acting person, one chooses the largest possible aspect, naturally, because then the object appears most distinctly. An animal or a man shooting his arrow is painted in profile, a man with raised arms from the front. Sometimes even the two largest aspects are combined into one to achieve more efficacy, even at the cost of reality, as, for instance, the lower part of an archer in frontal view, the rest in profile, or the man who throws a spear in frontal view, but the spear in profile. The swan of John Boss (pl. 16) shows itself with a bent neck – in profile – but with both wings as seen from underneath.

Negligence in space: In a composition an object may be placed at another spot than where it actually acts in the story, if thereby the significance or the aesthetic efficiency of the picture is heightened.

Example 1: As related on page 21 pl. 14 an ancestor of Charles once shot two reindeer and caught five more in a dug-out trap in one day. It is not possible to paint all five deer inside the circle which represents the hole since this would destroy the balance of the picture for it would leave the grandfather with only two deer outside the circle. Therefore only one deer is placed inside the trap

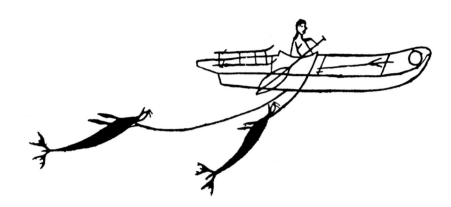

99 Two lovetug-seals were killed; to take them home, one was fastened at the belt (Painter Timothy)

circle and the other four animals share the outer space with the remaining three figures.

Example 2: Kusma drew a man for me who was so strong he could carry a huge stump of a tree to the men's house for a sweat bath all by himself on his shoulder. Kusma did not think of a presentation in profile but showed the man as seen from the front, with a stump in front of his stomach, for otherwise he would have had to omit either the face of the man or the stump.

Example 3: Only for aesthetic efficacy does John Boss paint the two birds which his ancestor caught in a fishnet not inside the net but places them symmetrically on the two stakes which hold the net (pl. 61).

In every case the narrator calls attention to this deviation from reality. "You must imagine these reindeer inside the trap – I have painted them outside".

De-composition: In a painting or sculpture a living being may be disintegrated into its main parts and re-assembled in a different way, if thereby the efficacy of the work of art is enhanced. For the Eskimo the body and limbs of a living being are so to speak stuck together. So he takes the liberty to change them in this sense. The body only holds the limbs, it is without characteristic quali-

ties and may therefore even be totally omitted.

Examples: The most frequent application of this rule is with the masks. The face of animal or man is large, the limbs are carved in miniature and are inserted into the frame of the mask in the same way as they "stick" in the real body: with a bird the legs below, wings on the upper sides, the tail between them as it appears when the bird is seen from the front. Thus the efficacy is heightened: the face as most expressive part gains in expression at the cost of the parts which are weaker and the least expressive part, the body, is totally omitted (pl. 32 and others).

Even more surprising is the application of this De-composition and Re-composition in certain paintings. There the outline of the body sometimes becomes independent of its natural appearance and its relation to the limbs. If on a wooden bowl the painter wishes to depict two animals, he may paint them both about equal size in the bottom of the bowl (pl. 102). But he may also choose to paint only one of them on the bottom. The other one he may paint around the bottom. To achieve this, he adopts a most extraordinary method, to my knowledge unique in the history of art: He represents the animal by its silhouette which he splits into two halves,

fits these along the rim of the bowl, then fixes the head, limbs and tail arbitrarily in places where in his judgement they weigh evenly against each other, and pointing inward, as if he had turned the animal's pelt inside out like a glove. Timothy had a dishmark in which he painted two animals, rather rare on Nunivak Island, a crow and a wolverine, which his ancestor caught at a short interval (pl. 101). A line drawn round the frame of the dish represents the body of the crow whilst head, tail, legs and wings project inwards.

Balance and symmetry

With all the better paintings the desire to balance the different parts of the picture determines the arrangement of the figures. The simplest means to achieve this are: sequence on a straight line (pl. 17), or in a circle (pls. 14, 15) and symmetry up to mirror-like equity of the two halves of the picture (pl. 100). This balance in the arrangement is often achieved at the expense of the clarity even of the correctness, of the scene. The whale is usually painted in his characteristic profile with eye and mouth (pl. 4). In figures 8 and 9 it appears as seen from above; only thus can the harpoon strings with their airbags be arranged symmetrically.

In the painting on page 80 (pl. 102) as a symmetrical counterpart to the curved fishspear above, the bird below is curved in the opposite direction. The examples quoted under "Negligence in Space" and "De-composition" also come under this heading.

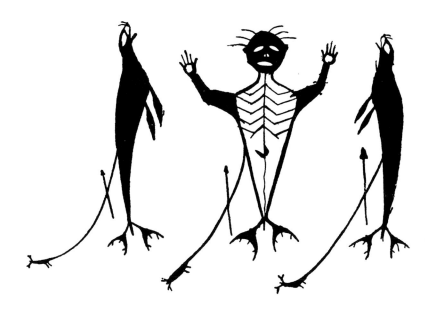

100 Bowl painting, significance unknown

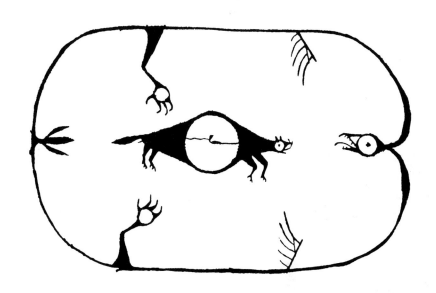

101 Bowl painting of a crow and a wolverine (Painter Timothy)

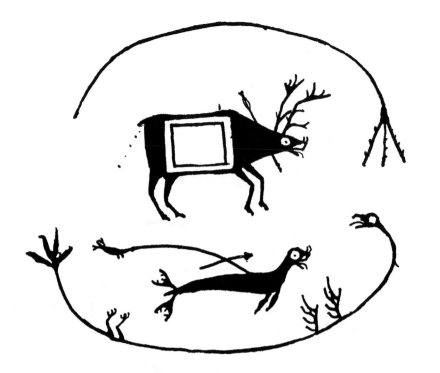

102 Bowl painting of an ancestor who killed a seal, an eider-duck and a reindeer on the same day (Painter Timothy)

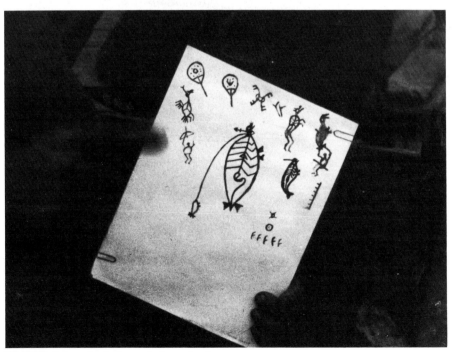

103 Paintings on a sheet of paper by Lame Jacob

Change of Dark and Light Ground

X-ray pictures. Some painters feel an urge to subdivide larger black areas by leaving some regular unpainted spaces. Within this void something black may be painted so that sometimes a threefold sequence of background and picture ensues.

Example 1: Free circular spaces in the bodies of animals (pl. 97) are sometimes used as background for further illustrations.

Example 2: Inside the black body of the reindeer (pl. 102) a white rectangle is left free and in this again another black rectangle is inserted. Timothy explains that he does this because a large black body would look ugly. (The story to this painting is this: A man killed an eider-duck and a seal in the morning. When he came home in the evening he was told that caribou had been seen. Before dark he went out again and killed one.) This principle of free space within figures which are then re-used for further paintings lead to "X-ray pictures". In these one paints ribs and intestines in the bodies of living animals (pl. 103).

I was always given an aesthetic reason for this procedure. An animal only in outline or as a black plain is considered tedious. Lame Jacob says: "Therefore we only do it if the painted animal is big. With little pictures it is not necessary."

Significantly, this is again an invention of the Eskimo down on the coast of the Bering Sea whom we have already come to know as the more skilful and ingenious artists. Up the river Kuskokwim this X-ray painting is unknown.

Most frequently this pecularity is observed in the family marks because these are meant to be especially beautiful, but it can also be applied on drum- and skylight painting. The representation is rather conventional. The ribs and the intestines are the most essential features. He who wants to be more explicit may add stomach and heart.

104 Cats cradle

Simplification of Form

Although Eskimo painting is created exclusively to relate a story it does by no means strive towards a naturalistic representation. The forms are much simplified with accentuation and special elaboration of the characteristics. Thus for a bird three lines suffice for the tail, four or five for the wings. This simplification may go very far. A good example is plate 20 where we can observe the transformation of a half-way naturalistic representation into an abstract chiffre of lines in a family mark.

As a counterpart the Eskimos show the gift to recognize pictorial contents in abstract forms. The Southwestern Eskimos see numerous meanings in the groups of stars. There is "the caribou" which John Boss drew for me in daylight just as it really looks at night, "the broken arrow", "the ladle", "the fox", "the strown out ones" and so on. The spots in the milky way are "the tracks of the old crow in the snow".

Under this heading of simplification of form fall also the cats cradles with their linear figures which are often hardly recognizable (pl. 104).

A string whose ends are tied together is wound around the fingers of both hands, until, sometimes only after twenty slingings, a figure appears between the hands, a caribou, a swan, a ptarmigan, a ship – sometimes several of them side by side, for instance a polar bear behind three men. Often the creation of such a figure alone is the point of the game, but usually some surprising change of the picture follows with a little change in the holding of the thread: the hare escapes, the polar bear bites into the man's leg, the sun sets between the mountains, the swan flies off and leaves just the lake.

Index of Artists

(* indicates artists originally from the coastal region)

Charly Coffee	St. Michael
Sando Vasil	St. Michael, from Stebbins
Jack Native	St. Michael, from Stebbins
Vasil	Napaskiak *
Zigeb	Tuliksak
Alexi I	Tuliksak
Nick Buluktuk	Akiatschak
Jimmy Lomak	Akiatschak
Ivan I	Kwethluk
Lame Jacob	Bethel, fishing camp
Maggie Lind	Bethel
Vasil	Jestlands Post
Illurak	Quillindok
Ivan II	Jestlands Post
***	Kipnak *
Peter	Pupok *
Andrew Minchalachla	Kukok *
William Aitazluk	Kukok *
Louis	Kukok
John Boss	Bethel
Paul	Bethel
d	Bethel
Kusma	Bethel, fishing camp
Andrevska	Bethel, fishing camp
Charles	Bethel, fishing camp *
Betka	Bethel, fishing camp
Alexi II	from an unknown town on the lower Kuskokwim
Andrew II	Bethel, fishing camp
Timothy and others	Nunivak Island

82

Bibliography

(Only publications quoted in the original German edition of 1938)

Anderson, Dewey, H., Alaska Natives. Stanford University Press, 1935.

Bär und Helmersen, Beiträge zur Kenntnis des russischen Reiches und der angrenzenden Länder Asiens. St. Petersburg 1839.

Barnum, Rev. Francis, Grammatical Fundamentals of the Innuit Language as spoken by the Eskimo of the Western Coast of Alaska. The Athenaeum Press, Boston, U.S.A. and London 1901.

Boas, Franz, Decorative Designs of Alaskan Needle Cases. From the Proceedings of the United States National Museum, vol. XXXIV, July 15th, 1908, p. 321–344.

Chapman, John Wight, Notes on the Tinneh Tribe of Anvik, Alaska. Congrès International des Américanistes, 15e session 1906. Quebec 1907, p. 1–38.

Curtis, Edward S., The North American Indian, vol. XX, 1930.

Dall, William Haeley, Alaska and its resouces. Boston 1870.

– On Masks, Labrets and Certain Aboriginal Customs... Bureau of American Ethnology, 3rd Annual Report 1884.

– Tribes of the Extreme Northwest. United Stated Geographical and Geological Survey I, 1877, Pt. 1, p. 1–156.

De Laguna, Frederica, A comparison of Eskimo and Palaeolithic Art. The American Journal of Archaeology, Vol. XXXVI, No. 4, Oct.–Dec. 1932.

– Indian Masks from the lower Yukon. American Anthropologist, October–December 1936, Vol. 38, No. 4.

Gordon, George Bryon, In the Alaskan Wilderness. Philadelphia 1917.

Hawkes, Ernest William, The dance festivals of the Alaskan Eskimo, Philadelphia, The University Museum, Anthropological Publications 1914.

– The "Inviting-In" Feast of the Alaskan Eskimo. Canada Department of Mines, Geological Survey, Memoir 45, No. 3, Anthropological Series, Ottawa 1913.

Hoffmann, Walter James, The Graphic Art of the Eskimos. Based upon the collections in the National Museum. Annual Report of the Board of Regents of the Smithsonian Institution for the year ending June 30th, 1895. Washington Government Printing Office, 1897.

Holmberg, H. J., Ethnographische Skizzen über die Völker des russischen Amerika. 1. Abt. Helsingfors 1855.

Hrdlička, Ales, The Eskimo of the Kuskokwim. American Journal of Physical Anthropology vol. 18, no. 1, July/Sept. 1933.

– Anthropological Survey in Alaska. 46th Annual Report of the Bureau of American Ethnology, 1928/29.

Jenness, Diamond, Eskimo Art (betr. eine Sammlung moderner Bleistiftzeichnungen von Eskimo). The Geographical Review, vol. XII, 1922, No. 2, p. 161–174.

Nelson, Edward William, The Eskimo about Bering Strait, 18th Annual Report of the Bureau of American Ethnology, 1896–1897 (XVIII). Washington, Government Printing Office 1899.

Petroff, Ivan, Report on the Population, Industries and Resources of Alaska. Washington 1884.

Weyer, Edward Moffat jr., The Eskimo, Yale University Press, New Haven, 1932.

Woldt, A., Capitain Jacobsen's Reise an der Nordwestküste Amerikas 1881–1883. Leipzig 1884.

Wrangell, F. von, Statistische und ethnographische Nachrichten über die russischen Besitzungen an der Nordwestküste von Amerika. St. Petersburg 1839, Ed. von Baer und Helmersen.

Zagoskin, Lieutenant A., Deutsch in Ermans Archiv für wissenschaftliche Kunde von Russland, vols VI und VII.

For literature on the Southwestern Eskimo and their art published after my stay in Alaska read notably the books by Dorothy Jean Ray, Margaret Lantis and Wendell Oswalt, and consult the bibliographies in their works.

"May all my small mistakes go into their places
and make little noise."

With this phrase Eskimo story tellers of Nunivak
used to end their tales.